FUN IN PHOTOGRAPHY
SPECIAL EFFECTS AND TRICKS

FUN IN PHOTOGRAPHY
SPECIAL EFFECTS AND TRICKS

**LIDA
MOSER**

AMPHOTO
American Photographic Book Publishing Co., Inc.
Garden City, New York

This book is dedicated to Franz Schubert, whose music helped me to write it, and to my grandniece, Andrea Lorraine Hewitt.

Table of Contents

Introduction

What do you do with a camera? For most people, it is enough of a challenge to point the camera at what's in front, press the button, and get a good picture.

However, this book is for people who want to go further, who want to experiment, who want to be able to take a camera and color film and create images that are unique and original, and their very own. These people want to find out how to bend the rules, how to extend the limitations and boundaries of the film and the camera and mold what is in front of the lens as a sculptor molds clay. They want to create pictures that express their imagination, their fantasy. They want to create pictures where the elements of mood and emotion are emphasized.

This book will explain how to put together in one picture things that are far apart in time and space, how to add or change color, how to capture the sense of movement, how to create an image that will delight, intrigue, and startle.

Some people will call this "trick photography," but it is more than that. I think it is being a magician, or better yet, an artist.

Some of the techniques and methods I've developed, which will be fully described and explained in this book, were used to make the following pictures of:

- A 25-cent aluminum funnel turned into a flying saucer over the skyline of Manhattan.
- A girl, photographed in the studio, seen running from a dark and mysterious old Victorian house, at night.
- A beautiful face in a field of flowers.
- A spirit emerging from a brick wall.
- The face of a man, and the girl who was dreaming of him.

- A painting on an artist's head.
- A man's head, stretched and duplicated.
- A leaping dancer flying.
- A city on the side of a girl's face.
- A man meeting himself on the beach.
- An American Indian in the desert sky.
- Crossbeamed lights coming out of a man's eyes.
- Two people—who never left the studio—in the jungle.
- The horizon of the Sahara Desert across a girl's eyes.
- Ghostly skeletons around a skull.
- A galaxy in a dark sky (created with shiny metal auto accessories, wire, and aluminum foil).
- A person floating below the surface of the sea.
- An eye coming through the clouds of the sky.
- A tin toy turned into a man living in a fiery world.
- Wild abstracts made from pieces of colored foil.
- One profile turned into six, in three different colors.
- A crystal ball turned into a colorful planet floating in space.
- The sea, the sky, and the clouds on a man's face.
- A ballerina in the center of a man's eye.
- A person, wrapped in plastic, turned into two dancing ghosts.

These effects were achieved primarily by double exposing, but also by sandwiching two or three slides, using optical devices and filters, varying the focusing and the time exposures, using black-and-white photographs and adding color to them, using projected color transparencies, and last but not least, utilizing many different types of reflective surfaces.

The most adaptable type of camera for this kind of work is a 35mm single-lens reflex. However, once you have mastered the various techniques, they can be applied to almost any kind of camera. All the techniques and methods that will be described can be applied by you; and once you are finished shooting and the film is out of the camera, you need only process the film in the ordinary way. Nothing further needs to be done.

Let us hope that you will find your way, as I have, into an exciting area of photography, one that will give you a great deal of pleasure and allow you to express yourself.

It has often been said in many ways by many people that creative work is a form of play. This work, I assure you, is creative; so let's have fun!

1

Double Exposures

Before you enter the creative world of double exposure, there is one ability that must become second nature to you. You must learn to look at a color transparency and see, not what is pictured, but the light areas, the middle-toned areas, and the dark areas. You must learn to think of film as a blotter that soaks up light. Where the light doesn't hit it, the film remains unused.

The area of Fig. 1-1 shown in Fig. 1-2A, the highlighted side of the girl's face, has completely used up the film, and will come through and dominate anything you double expose on it; your second exposure will register on the film only in the areas shown in Figs. 1-2B and 1-2C. In other words, the light area, which is actually a very small portion of the film, is all that has been completely used, the middle-toned area has been partially used, and the dark areas have not been used at all. The latter two areas can absorb other images and colors. Figs. 1-3A and 1-3B are two other possible types of pictures, with tonal-area analyses.

I cannot stress enough the importance of developing the ability to analyze color transparencies in terms of tonal values.

PREPARING TO DOUBLE EXPOSE

There are two basic ways to double expose. You can double expose frame by frame as you go along; most cameras have a device to allow you to do this. Or, you may shoot off a set of pictures on a whole roll of film, and then when you are finished, put the roll of film through the camera again, right away, in a day, or even in a month. Personally, I prefer this second method; it allows more flexibility. You can take many different types of pictures without having to worry about double exposing right away. If you use this method, keep notes and records of the first

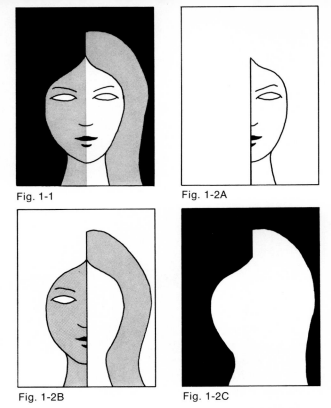

Fig. 1-1 Fig. 1-2A

Fig. 1-2B Fig. 1-2C

Fig. 1-1 is a simplified illustration of a girl's head lighted from
the side, against a black background. Figs. 1-2A to C show
the three main areas of Fig. 1-1 in terms of highlights (A),
middle tones (B), and dark tones (C).

Fig. 1-3A. The double exposure will regis- Fig. 1-3B. Only the highlighted figure will
ter on the dark area of the body. come through; the double exposure will
 register in the dark area around the body.

exposures, so that you will have a guide when you make the second exposures on top of the first exposures. Say you have photographed someone in close-up, medium, and full shot, as in the illustrations below; for the second exposures there are several things you can do. You can double expose with the same or other persons; you can use abstract color designs; or, you can use country scenes, flowers, trees, city scenes, traffic, crowds, or objects. These are some of the possibilities. The next chapter will have very specific instructions for your first roll of film to start you off; subsequently you can try to do whatever you want.

Fig. 1-4. One possible series of first exposures, as seen through the viewfinder. Frames 1 to 6 are close-up shots of the model, frames 7 to 13 are medium shots, and frames 14 to 20 are long shots.

Preparing the Film

When you put a fresh roll of film into the camera and you plan to double expose with it, you must prepare it in the following way, in order to prevent the film leader from going back into the cassette when you rewind it after the first exposure, or the first-image layer of *take I* (as I will be referring to it): You must fold the film back from the end of the leader with two 1/8" creases (Fig. 1-5).

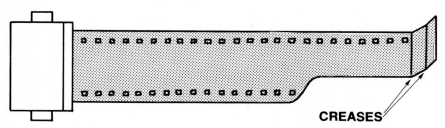

CREASES

Fig. 1-5. Crease the end of the leader.

When loading the film onto the take-up spool, fold back these two creases and push them into the slit. Upon retracting the film, you will see that the creases catch inside the slit of the take-up spool, and act as a

stop. When you remove the back of the camera, you will see that the film leader is outside the cassette. Another way I have of keeping the film leader from disappearing into the cassette is to rewind slowly and hold the camera near my ear. I listen and can hear when the cut-away portion of the film comes off the top sprocket wheel. I stop at this point to make sure that the film is still attached to the take-up spool, or the end of the film is at least outside the cassette.

Let us go back to the point when you load the camera for the first exposure. You have made your two creases at the end of the film leader, you insert them into the slit of the take-up spool. You move the film forward one or two frames to make sure that it has caught properly. At this point, you take a ball-point pen and draw a line on the film along the edge of the opening of the cassette (Fig. 1-6).

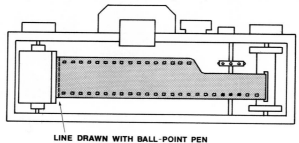

LINE DRAWN WITH BALL-POINT PEN

Fig. 1-6. Draw the first line.

With the back still off the camera, press the release button and move the film forward one more frame, and again, with a ball-point pen, draw a line on the film along the edge of the cassette opening (Fig. 1-7). Count the sprocket holes between the two lines. If there aren't eight sprocket holes, you must repeat the process; by the third time, the film should be moving forward a full frame at a time, a full frame containing eight sprocket holes along each edge.

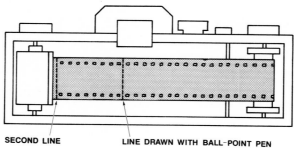

SECOND LINE LINE DRAWN WITH BALL-POINT PEN

Fig. 1-7. Draw the second line.

You now have two lines drawn on the film; press the release button one more time and move the film forward one more frame with the back

still off the camera. You should have two lines drawn on the film and eight sprocket holes between the second line and the edge of the cassette (Fig. 1-8).

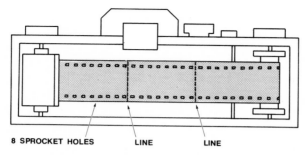

8 SPROCKET HOLES LINE LINE

Fig. 1-8. Make sure there are eight sprocket holes between the line and the edge of the cassette.

Only now do you close the back of the camera; you are ready to start shooting. When you have finished the whole roll of film, you must rewind the film carefully, as described above. The creases have acted as a brake, and you can open the back of the camera. Ideally, the film should be as it is in Fig. 1-6, with the leader still attached to the take-up spool. If you plan to put the roll through again immediately for your second take, do not remove the film from the camera, or the leader from the take-up spool. Press the release button and move the film forward, first one frame, then one more. Almost always, you will find that the ball-point pen marks are lined up properly, as in Fig. 1-8. I have personally put a roll through four times, one time right after the other, and, using this method, have always had the film line up correctly.

This marking of the film is very important in doing the work presented in this book; a marked film will be referred to from now on as a "prepared" roll. Of course, you could start your own procedure and purposely not have the frames lined up. There's no reason not to do this. I just have never done it. I know people who have, and they have gotten some very interesting compositions. In Chapter 10, you will find a description of a series of pictures photographed this way.

Let us assume that you have finished the first shooting on a "prepared" roll of film and removed it from the camera with the leader outside the cassette opening. Some time has elapsed, and you are ready to put it back into the camera for your double exposures. Don't be alarmed if it takes several tries before the ball-point pen marks across the film line up properly. The first time I made my planned double exposures, it took a half-hour to get the film lined up properly, but I finally did succeed. Be patient and keep at it. The marks will line up eventually. It's usually a case of changing the length of the leader, or making another crease or two.

2

Using Double Exposures

This book, hopefully, will be read by people in all stages of photography, from experienced professional photographers to people who are perhaps one step beyond just having started taking pictures. Such people have been in photography long enough to have gained a certain ease with the camera and know the basic rudiments: how to use a light meter, how to adjust the aperture and time settings, and how to load film. This doesn't mean that this is simple or easy work. It can get quite complicated, and it entails hard work and logical thinking, but I truly believe that even if you have recently started taking pictures you can succeed, if you have the courage and the desire to try out new ideas and to follow explanations and instructions carefully.

If you feel you understand the concepts in Chapter 1, you should now get ready to take pictures. Perhaps you might read the text more than once, until the relationships between the light areas and the dark areas, and the functions they serve, are clear to you.

My feeling is that if you do the work as we go along in this book, we can think of the work as a discourse between two people working together at the same thing, as an exchange and a friendly sharing of day-to-day experiences. The actual doing will clarify the explanations, and when your first completed roll of film is returned to you from the color-processing laboratory you will have the added thrill of seeing results, and your understanding of what you have read will be reinforced and, I assure you, clarified.

We are going to stop here to define certain words and phrases that will be used frequently throughout the book.

Many of the types of photographs described and explained in this book are commonly called *double, triple,* or even *quadruple exposures.*

However, when I'm giving a step-by-step explanation of a specific shooting problem the words *exposing* or *exposures* will be used only in reference to the light-meter readings, and the aperture and time settings. Only in general discussion will I call a slide or transparency a double exposure, a triple exposure, or a quadruple exposure.

In the specific explanations, the first shooting on a roll of film will be referred to as the *first take*, not the first exposure, although in reality it can be called that. When the roll of film is put through the camera a second time, it will be called the *second take*. Each succeeding time the same roll of film goes through the camera, it will be referred to as the *third take*, the *fourth take*, or as *take I, take II*, or *take III*, and so on.

Instead of saying, "You now make your first exposure," I will say, "You now take the picture," or "You now press the button." When a fresh roll of film is put into the camera for the first time, the language used will be, "You now get ready for your first take," or "You now do take I" or "You now make take I." I repeat, the terms *double exposure*, *triple exposure*, and the like will be used only when a general reference is made to a picture.

Since this book deals almost exclusively with color photography, the terms "slide," "transparency," "picture," "photograph," and "shot" will be used interchangeably to refer to the same thing, that is, a slide of transparent color film, usually a 35mm color slide. There will be a few times when 2¼" × 2¼" or 4" × 5" transparent color film will be used, but it will always be designated by size. A black-and-white photograph will always be referred to as a black-and-white photograph or a b & w photograph.

Throughout the book, I will refer to your "studio." Your studio can be anything from a fully equipped professional establishment to a corner of a room where you control the background and the lighting.

FIRST DOUBLE-EXPOSURE SHOOTING

Just to get you started I'll list the things you will need for the first shooting:

1. Model, preferably a patient and loving friend.
2. 35mm camera with a normal lens.
3. Roll of High Speed Ektachrome Film (Tungsten), 35mm, 20 exposures.
4. Tripod.
5. Light meter.
6. Lighting equipment (at least one 250-watt, 3200 K bulb in a 10" or 12" reflector).
7. Masking tape.
8. Optional: "barn doors" to control the spread of light on your reflector floodlight, or two strips of black paper about 5" × 14" to

be taped to the side or sides of the reflector. Although it's not usually done, I often push in the sides of the reflectors (Fig. 2-1). These oval reflectors are very handy, and help shape the spread of your light.

Fig. 2-1. Left, the reflector sides in the normal position; right, the sides of the reflector pushed in to help focus the light.

9. Colored gelatins for your lights, or several rolls of cellophane in different colors (red, blue, green, orange, violet, yellow, pink), generally found in gift-wrapping shops. You can tape the sheets of cellophane to cardboard frames, which you hang on the reflectors.
10. Black background paper.
11. Slide sorter and slide viewer.
12. Slide projector.

Loading the film is extremely important; you should do it carefully and with precision. Keep the book open to the appropriate pages and meticulously follow the instructions and explanations given with Figs. 1-5 through 1-8.

With the camera loaded and ready for shooting, you can now begin work with the model. The model should be wearing a dark garment. Have your model sitting on a backless chair at least 2¹/₂ feet in front of a black (or very dark) background. Place the light to the left of the model.

At this point you should be concentrating on lighting, composition, and exposure. The rapport between the model and the photographer, and the model's facial expression, are not important. That is why the model should be a patient and loving friend who is sympathetic and will not distract you from technical matters. Later on, after you have done several rolls of film using these techniques, you can work on expression.

Look through the viewfinder of the camera and move forward or back until your composition resembles Fig. 2-2. There should be no light on

Fig. 2-2. Take I.

the background, and there should be very little light on the shadow side of the model's face. If necessary, put baffles on the reflectors. You can use barn doors, which attach to the reflector and help you control the light. Or, you can make baffles out of the oblong pieces of black paper; attach them to one or both sides of the reflector with masking tape.

Now you take the light readings: first, on the background; second, on the shadow side of the model's face; and finally, on the highlighted side of the face, the left side. This last reading is the important reading; the other two should fall below it. The reading on the shadow side of the model's face should be at least three stops lower than the left-side reading, and the background should register nothing. If this isn't the case, you must adjust your light. You can make the background darker by bringing your model forward from it.

The reading on the highlighted area is your keystone. This is the only reading you are concerned with for the shooting. As you aren't skilled at doing this kind of work (though you soon will be), do all steps slowly and deliberately.

Let us assume that your reading on the highlighted area of the face is $f/4$ at 1/30 sec. (A different reading is possible, of course.) After you get the light reading, and before you start to shoot, make an exposure chart. Next to each frame number, write the exposure setting that you will shoot at; and when you are shooting, follow the chart precisely.

The exposures you shoot at should be charted, so that you will have a thorough understanding of how the results were achieved. At this stage there should be no mysteries or surprises. There will be plenty later on.

In multiple shooting a wide range of exposure bracketing is used. Right now you should bracket from 1¹/₂ or 2 stops under the reading through 1¹/₂ or 2 stops over the reading and all the half-stops in between. Later on, when you see how the bracketing works, you needn't use such a wide range.

EXPOSURE CHART
Take I Light Reading, *f/4* at 1/30 sec.
High Speed Ektachrome Film (Tungsten)—ASA 125

Frame #	Take I		Take II	Frame #	Take I		Take II
1	*f/4*	1/30		11	*f/4*	1/30	
2	*f/4–5.6*	"		12	*f/2.8–4*	"	
3	*f/5.6*	"		13	*f/2.8*	"	
4	*f/5.6–8*	"		14	*f/2–2.8*	"	
5	*f/8*	"		15	*f/2*	"	
6	*f/8*	"		16	*f/2–2.8*	"	
7	*f/5.6–8*	"		17	*f/2.8*	"	
8	*f/5.6*	"		18	*f/2.8–4*	"	
9	*f/4–5.6*	"		19	*f/4*	"	
10	*f/4*	"		20	*f/4*	"	

On the second take, you must make sure that you get as many combinations of exposures as possible. I work by varying only the apertures, but you may also want to vary the time settings. But again, let that come later on, when you feel you understand the effects of the variations. The fact remains that the second take feeds extra life and exposure into the underexposed areas of the first take, and this is what you have to get the feel of. This feeling can only come through the experience of shooting, seeing your results, and checking back to the chart.

Only after the chart is made do you shoot. Shoot strictly according to your notations on the chart. If you feel that it will be helpful, use a tripod. (I do not like to use a tripod, except when absolutely necessary.)

As soon as you have completed shooting the 20 frames of take I, you rewind the film as described earlier. When you can feel you've come to the crease at the beginning of the roll, double check by removing the back of the camera and seeing that the ball-point pen lines are lined up correctly against the opening in the cassette as you advance the film one or two frames.

Fig. 2-3. Take II.

Close the back of the camera and you are ready for take II. Just move the light to the other side, the right side of the model. Place it so that there is as little light spill as possible on the shadow side of the face. To add a little interest, move the camera back about one foot and tilt it slightly downwards, so that the model's head is higher in the frame. If you wish, you can also tape a gelatin or cellophane *scrim* (light-diffusing panel) over the reflector floodlight. Study the effect of the colored scrim on the model's face. If you use cellophane, you may need more than one layer to have the face affected by the color. I have chosen these variations at random; there are many other things you might do. You might move the camera closer to get a larger image, or you might use another person. There are an infinite number of possibilities, and they will come later; for now, let us stay with these simple variations.

You are ready to take your light readings for take II. Do them exactly as you did the readings for take I: first on the background, then on the shadow side of the model's face, then on the highlighted side. The readings should be similar to the ones for take I. The colored scrim may reduce the light reading somewhat, depending on the depth of the color, but you can bring the light reading up by moving the light closer to the model (Fig. 2-3).

Before shooting take II, you must go back to the chart and fill in the aperture openings for take II. If you study this chart you will see that there are very few repetitions of aperture combinations. I also suggest that you throw frames No. 3, 6, 10, 17, and 19 slightly out of focus for take II. It will give you another variation to study when you see the results.

EXPOSURE CHART
Take I Light Reading, *f*/4 at 1/30 sec.
Take II Light Reading, *f*/4 at 1/30 sec.

Frame #	Take I		Take II		Frame #	Take I		Take II	
1	*f*/4	1/30	*f*/4	1/30	11	*f*/4	1/30	*f*/4–5.6	1/30
2	*f*/4–5.6	"	*f*/4	"	12	*f*/2.8–4	"	*f*/5.6	"
3	*f*/5.6	"	*f*/4	"	13	*f*/2.8	"	*f*/5.6–8	"
4	*f*/5.6–8	"	*f*/2.8–4	"	14	*f*/2–2.8	"	*f*/8	"
5	*f*/8	"	*f*/2.8	"	15	*f*/2	"	*f*/8	"
6	*f*/8	"	*f*/2–2.8	"	16	*f*/2–2.8	"	*f*/5.6–8	"
7	*f*/5.6–8	"	*f*/2	"	17	*f*/2.8	"	*f*/5.6	"
8	*f*/5.6	"	*f*/2–2.8	"	18	*f*/2.8–4	"	*f*/4–5.6	"
9	*f*/4–5.6	"	*f*/2.8	"	19	*f*/4	"	*f*/4	"
10	*f*/4	"	*f*/2.8–4	"	20	*f*/4	"	*f*/4	"

After you have completed take II, make sure that your color-processing laboratory numbers the individual mounts sequentially. This is very important, as it enables you to study the transparencies and correlate them with the frame numbers on your chart so that you can comprehend how all the various elements interact.

When your slides are back from processing, you should study them carefully. There are four ways of looking at them:

1. Hold them up and look at them with a light behind them.

2. Put them on a slide sorter or light box (Fig. 2-4). These cost from $5 to $30 and up. An inexpensive one is adequate for your present purpose. Spread the slides out in numerical order and study them along with your exposure chart. The advantage of using the slide sorter is that you can look at a whole roll at once and see the effect of all the variations. Using a magnifying glass can be helpful. Subsequently, you might want to study the slides individually.

Fig. 2-4. The slide sorter.

Fig. 2-5. Take I and take II on the same frame. Each take fills up the dark area of the other.

3. Put them on a slide viewer; the slides are lit up one at a time, and enlarged two times or more.

4. Use a slide projector, which is the most exciting way of seeing slides, even "bad" ones. Very often, when you are projecting slides, you discover things in them that you wouldn't see if you viewed the slides the other three ways.

Time spent studying your slides is very well spent. From it you can derive new ideas, decide what you would like to change, and discover the effect the two takes have on each other. You can determine what kind of an exposure bracketing spread you want. You may decide to eliminate one or two of the aperture openings, or use them only in special cases.

If you have followed instructions carefully, your results should look something like Fig. 2-5.

An exposure in which the image of take I is brighter than the image of take II may provoke a mood that is totally different from the reverse combination. The brighter slides could be interpreted as being gay, dreamy, or happy. The darker images may create a mood that is mysterious, ominous, or sad. You will eventually learn how to control and create images to impart a specific mood and emotional quality. So, the "correct" exposure is not necessarily what we are after, but rather an exposure that gives us what we are trying to achieve or "paint." Right now, even so-called mistakes can be a way of discovering the limits and outermost boundaries we can reach. Ideally, you will be satisfied with your first results. You will see what you can do, and you will be encouraged to go on to your second roll.

21

SECOND DOUBLE-EXPOSURE SHOOTING

The directions for the first shooting may seem to be very disciplined and rule-bound, but in this kind of photography, where the accidental can play such an important role, where the range of possible combinations can be endless, loose, and wild, I think it is best to operate from a strong base, slowly and carefully. The seemingly simple double exposing of heads has so many variations. It is like the surface ripples that go on and on when you drop a stone into a pond.

You should refer to the exposure charts in the previous section before you start shooting the projects presented in this section. Copy the form used for the above exposure charts, and fill in the aperture and time settings after you take your light readings.

Also, make sure you mark the film with your ball-point pen when loading the camera. This should become automatic. Although right now we are setting out to deliberately double expose, later on you may find that sometimes while shooting and not having planned to double expose, you may suddenly want to double expose, even for part of the roll. If your film is marked, you will be able to double expose.

Below are diagrams to follow for this shooting; after this, however, you will be making your own diagrams. The exposure charts, the diagrams, and the notes you make will prove to be very important and valuable to you.

For this shooting you will need all the things listed on pages 15 & 16, except this time we'll use a 36-exposure roll of film so that we have more leeway.

If your lens does not focus close enough to fill up the whole vertical-frame area with a head, you will need a close-up attachment. It costs about $10.

Place a colored-gelatin scrim, or attach loose sheets of colored cellophane, on your light reflector with masking tape. Use any color you wish.

You start this shooting the same way you started the first shooting. Your model is seated in front of a dark background. Place the light to the left of the model as you did in the first shooting. Take your light reading, and fill in the aperture and time settings on your exposure chart for frames 1-12. If you have decided to limit your bracketing spread after studying the results of your first roll, do it now; but I assume that you will want to do some bracketing. For frames 13-24, turn your model around for a profile. If you have changed the scrim, check your light reading. Fill in the aperture and time settings on your chart. For frames 25-36, remove the close-up attachment and move back with your camera. Again, take a light reading and fill in the aperture and time settings on your exposure chart.

22

Now we are ready for take II. Retract the film, check the lines you drew on it near the leader, and move it up to frame No. 1. Move the light around to the right side of the model, and pick one of the following suggestions, or anything you think of yourself. Don't worry if some of your efforts fail. This is a time of learning, and you can learn a lot from mistakes.

Frames 1-12.

Fig. 2-6. Frames 1 to 12 of take I are close-up shots of the face, frames 13 to 24 are profile shots. For frames 25 to 36, move back with the camera so the face occupies a smaller area of the picture. If you like, you can change the color of the scrim every six frames. Each change in type of shot and each change in color will give your final picture a different effect.

Frames 13-24.

Frames 25-36.

I should also like to tell you that all these shots can be done with a normal lens, so if you don't have a close-up attachment, don't let that stop you. Your closeups may not match the diagram, but they will be good enough. As for the long shots that are on the following list of suggestions, I don't know what kind of a space you will be working in, but I presume that you will be able to get far enough away from your model to be able to shoot with a normal lens. However, for more spread and more flexibility, now and later on, it would be good to have close-up attachments; or, if you're lucky, a close-up lens, and also a wide-angle lens. Substituting a 35mm lens for your normal lens while shooting gives you something extra to work with, and I have found that it even stimulates new ideas.

Suggestions for Take II's

1. Do the same size heads, lighted, of course, from the opposite side, with different colored scrims and with the highlighted side of take II right on top of the shadow side of take I, so that the two highlighted sides are close. Throw some of the frames out of focus.

2. Put the model in a costume and do a medium or long shot.

3. Use a second model, someone of the opposite sex or a child or a much older person, and make close-up, medium, and long shots (Fig. 2-7).

4. Remove the camera from the tripod, put the time setting on a slower speed (1/15 sec., or 1/10 sec., or 1/5 sec.), and introduce camera movement. In this case, remember to compensate for the slower speeds with smaller apertures.

5. Try a piece of clear but slightly crumpled cellophane in front of the lens to get a diffused, hazy effect (Fig. 2-8).

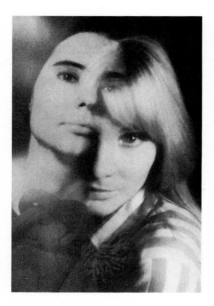

Fig. 2-7. A different person was used for the second take in this double exposure.

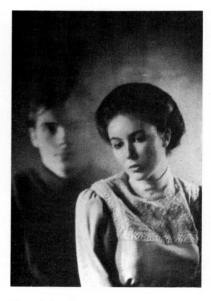

Fig. 2-8. The slightly out-of-focus young man and the halo around the girl give this double exposure a dreamlike quality.

I don't know if you can visualize the effect of some of these combinations before shooting, but since I've already done them I would like to tell you what you should expect.

With a combination of a child and a much older person, you might get the feeling of a parent with a child, or a sense of the cycle of generations, especially if the sizes of the heads in the picture are varied. In the pictures with a man and a woman, if both takes are on the light side or diffused or if one take is darker than the other, you can get a romantic or dreamy feeling. If both takes are on the dark side, perhaps it would seem as though something is pending or mysterious.

Something curious happens when you're photographing two people in this way, and I'd like to stop here and examine it with you. There are many photographs taken of two people together, in the usual classic single-take way, but for some reason two people photographed on the same frame at different times by this double-exposure technique provoke a unique effect. I'm not quite sure, but I would say it could be an enigmatic effect, as though something has been indicated or implied but not quite revealed; in any case, it seems to draw the viewer into the picture. We could go into a psychological analysis, but I prefer to acknowledge the existence of this quality, and go on creating pictures.

When I'm finished shooting, I send the films to a local processor and see results in three to five hours. Film can be "pushed" and "dropped" in the processing to increase or decrease the ASA rating, which is important, because there will be times when you will be taking pictures with insufficient lighting or too much lighting. If you make notes during the shooting, and then instruct the lab that you're underexposed or overexposed, they can "push" or "drop" the development of the film from 1/4 of a stop to 2 stops, and even more, as per your directions. (Personally, I've never gone beyond two stops.) This has nothing to do with bracketing. It merely brings all your bracketing into line, and converts the center aperture setting into a "normal" exposure. "Pushing" and "dropping" do affect the color and the grain. When High Speed Ektachrome (Tungsten) is "pushed," thus increasing the ASA rating, the color goes reddish. When this film is "pushed" not more than 1 stop, you can hardly notice the color change and the increase in the grain. The changes become apparent when the "pushing" goes beyond 1 stop.

Daylight Ektachrome goes blue-red or magenta when "pushed." Similarly, the color and grain changes are hardly noticeable when the film is "pushed" not more than 1 stop. The changes begin to be apparent when the "pushing" goes beyond 1 stop.

If you are overexposed, then you can advise your color processing lab to "drop" the film during the processing, and thus decrease the ASA rating. The color and the grain of the film is also affected by "dropping." With the daylight-type film, "dropping" causes a shift in the color to the green side, and to the yellow-green side with the tungsten-type film. Again, these changes are practically imperceptible when the film is "dropped" 1 stop or less, and only begin to be apparent past 1 stop.

I feel that these shifts in the color can be discounted for the kind of work that we are doing, considering the advantages gained by "pushing" and "dropping."

If you use other types of film and you have either too much or too little light, you should know that:

1. Kodachrome allows for no variation in processing.

2. Fujichrome can be "pushed" and "dropped" like Ektachrome.

3. Agfachrome can be "pushed" 1 stop only, and it can not be "dropped."

I haven't listed all the color transparency films, but that doesn't mean they can't be used. Use whatever film you wish, but I suggest that you check on whether or not it allows for variation in processing. In fact, checking *all* films periodically is a good idea because technical changes in the makeup of films can be made at any time.

3

Abstracts

Making *abstracts* with color film is an easy way to make beautiful slides and have fun as well.

Abstract slides are important to us because they combine very well with the other work that this book deals with. But we also create abstracts because there is a recurring need in us for this kind of temporary escape from reality—a need to float out on a visual cloud of sheer sensual beauty. We all love to see swirling shapes of different colors intermingling, melting into each other. Nature gives us these shapes in cloud formations and sunsets. Modern life serves them up constantly: Look at the streaks of moving lights on highways at night, or the reflection of bright lights on wet pavements.

Besides being beautiful, and a joy to create, abstracts are useful to have on hand for making "sandwiches," one of the techniques you will read about later in this book. Abstracts are also useful if you plan to put together slide shows.

If you look around carefully you can see that there is not too much natural color in the world; most of the color you do see has been created and added by people, i.e., with makeup, clothing, signs, printed matter, and paint. So, too, we can add an extra dimension to our slides by adding the color of abstracts. In multiple exposing, with abstracts as a second or third take, we can feed extra color into the shadow areas of the first takes and fill up dark backgrounds with shapes and color. Abstracts can vary from a single color with highlights to a collection of wild colors; and they can either be amorphous or very geometric (Plate 4).

There are several ways to make abstracts. You can use the camera and color film to obliterate the reality of anything you photograph by going extremely out of focus, or by using a slow time setting and moving the camera.

You can also have various objects and materials on hand and make an infinite variety of abstracts quickly and easily. These materials should have lots of color along with surfaces that will give you lots of glints and highlights.

Handy Objects for Making Abstracts:
1. Posters
2. Fabrics with strong designs and colors
3. Brightly colored paper
4. Christmas-tree balls and lights
5. Sequins
6. Rolls of colored foil or gift-wrapping papers
7. Aluminum foil
8. Rolls of clear, colored cellophane

The posters and fabrics can be photographed directly out of focus, with a slow time setting. You can do the same with the colored paper, balls, and sequins if you scatter them on a dark background. The foil, cellophane, and gift-wrapping paper can be crumpled and carefully lighted so that you get highlights and gradations of tones for making abstracts of single colors. Again, you should be out of focus. You might take several thicknesses of the cellophane, either one color or several colors, crumple them, and place a light behind them. Here you must be careful with your light reading as everything tends to be very bright and you can easily overexpose. The Christmas-tree lights can be taped on a black background. In taking the picture, I almost invariably set my camera speed on Time and move the camera.

I made my own special, favorite "abstract maker," and with it I get results similar to those you get with the Christmas-tree lights. In the center of an 18" × 24" black sheet of paper, I punch a cluster of $1/8$"-diameter holes. Each hole is backed with small pieces of colored cellophane. I attach the "abstract maker" with masking tape to the horizontal bar of a light stand. I place a light behind it. This light is usually a 250-watt bulb in a 12" reflector. I find this "abstract maker" very handy. It is easy to store, and I have used it often. There are three things I usually do when I use the "abstract maker":

1. I get very close to it, go very much out of focus, and get large, soft, overlapping circles of color.

2. I move to a position where the frame is filled with the color dots, use a sharp focus or a slightly soft focus, and get an abstract slide of color dots.

3. I set the aperture at $f/16$, and the shutter speed on one second, or Time (counting out two or three seconds), and deliberately move the camera around.

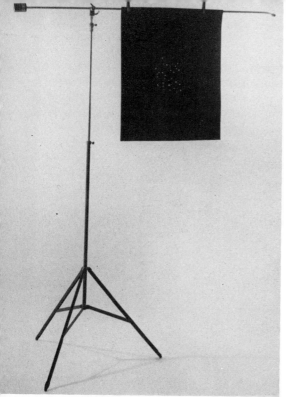

Fig. 3-1. The "abstract maker" attached to the horizontal bar of a light stand. Each hole in the central area of the black sheet of paper is backed by colored cellophane; a bright light is shined through the holes, enabling the photographer to create colorful abstracts.

g. 3-2. This black-and-hite contact sheet illustrates the kinds of pictures at can be made with the abstract maker." Keeping e camera focused on the ghts, and using the time-xposure setting and varying egrees of camera movement, will yield streaky patterns, while keeping the camera still but going very uch out of focus will yield ffused dots. In color, of ourse, the abstract-like effects are enhanced.

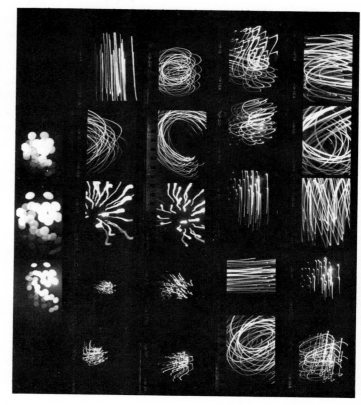

If you want to move the camera, there are several kinds of movements you can make. You can zigzag the camera. You can make horizontal, vertical, diagonal, wavy, erratic, jerky, and nervous quivering movements. You can hold still for part of the exposure and quickly jerk the camera for the balance of the exposure. Or, you can move in and out, to and from the board, during the exposure. When you make these movements, you are using the color dots to draw on the film, making lines of color and controlling the design. You will find that this is not the only circumstance when these deliberate camera movements are applicable. Later on in the book we will come to others.

You can manipulate the light reading by changing the size of the bulb and also the distance between the back of the board and the light. It is difficult to get an accurate light reading off the board; I do it by putting the meter very close to one of the holes, then to another and another, until I have some kind of average reading. After you see your first results, you will have a good idea of what your exposures should be, and then, obviously, you can have a record of the exposures, the bulb sizes, and the distance between the light and the holes.

All the instructions given above for the "abstract maker" can be applied to Christmas-tree lights taped to a black board. Records of the exposures should be kept. However, with the Christmas-tree lights, you cannot control the amount of light as you can with the "abstract maker," as the light from the bulbs is constant.

While working with abstracts, always press the depth-of-field preview button, to see what things look like at the aperture at which you will be shooting. This is important: If you are too much in focus, you can destroy the illusion. In photography we often struggle to get sharp focus, but sometimes, surprisingly, when making abstracts and other subject matter, we may want to use out of focus; and we may find that we have some difficulty achieving this. I have sometimes resorted to putting a close-up attachment on the lens to insure out-of-focus results. But remember, if you are too far out of focus, it can be too mushy and formless; so always use your preview button.

Another problem that can arise when making abstract slides is that sometimes you may have too much light, especially when you are shooting on a time exposure. For instance, with the black board with the holes in it, or particularly with the Christmas-tree lights, I have shot at $f/16$ for as much as four seconds in order to have extra time for camera movement and have cut down on the aperture by laying one or two spread fingers across the lens while exposing. This also affects the design; and the results are quite interesting, because you can't anticipate them. I've used the two-finger technique at other times too, especially when I've put the camera close to an eye-level, neon sign. (See Chapters 5 and 10.)

USE OF REFLECTIVE SURFACES FOR ABSTRACTS

Another way to create effective and unique abstracts is to take any of the aforementioned objects and photograph their reflections in different types of reflective surfaces. Each reflective surface has its own characteristics, and does its own special thing for you.

In this chapter we'll examine reflective surfaces as well as a device for creating abstracts only; but in later chapters we'll review the use of reflective surfaces for other projects.

Reflective Surfaces

1. Highly polished and shiny metal surfaces and objects, such as stainless steel, aluminum, silver, and the like.

There are an immense number of these objects around us in our daily lives, but to point out just a few of them: We have all seen those wonderful photographs that silver companies and pot and pan manufacturers run as ads. If you look closely at these pictures you will see, on the metal objects, abstract designs that are in reality reflections of the studios in which the photographs were made. These reflections are distortions created because of the shapes of the metal objects. Any such shiny metal object (which I'm sure you have) could be used to reflect colors, or other objects you place in front of them, and you could then photograph these reflections to create abstract color transparencies. You might want to get a sheet of metal stamped with geometric designs, the sort of thing you see on walls around stoves in restaurants. I have several pieces of these stamped sheets of very shiny metal and have used them many times.

2. Stiff, semi-stiff, and soft reflective plastic materials, such as mylar and polystyrene.

These are only two among many types of shiny plastics in various degrees of thickness and stiffness. Mylar, a soft plastic, has become a common material that can be purchased in art stores. I got several sheets of polystyrene (aluminum) .010″ thick from Coating Products, Inc., of Englewood Cliffs, New Jersey. I made extensive use of this material, which comes in colors other than the aluminum, and it became one of my favorite abstract-making devices. I hung it from the horizontal bar of a light stand that can be adjusted to a convenient height for shooting. When being photographed at slow speeds, both the mylar and the polystyrene will shimmer and undulate, creating interesting effects out of the colors reflected in them (Fig. 3-3). These plastic materials can also be bent and creased and made into tubes, arcs, and funnels. Colored objects become soft and flowing when reflected in these surfaces, like watercolor washes.

3. Mirrors—plain, curved, smoky, concave, convex, broken, or geometrically designed or cut.

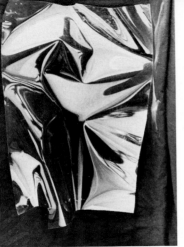

Fig. 3-3A

Fig. 3-3C

Fig. 3-3B

Fig. 3-3A is a bent sheet of polystyrene attached to a black cloth. Fig. 3-3B is a piece of black-and-white striped fabric. In Fig. 3-3C the reflection of the black-and-white striped fabric in the polystyrene becomes an interesting abstract composition.

Bear in mind that the flat mirror does not distort. The results you get with it aren't too different than photographing your abstract-making materials directly, except that it will double the distance between the reflected object and the camera, if that is necessary, and give you additional scope in a tight area. However, as the surface of the mirror deviates from being flat and level, so does it distort, and distortion is an important element of abstraction.

A broken mirror can be an extremely effective device for creating abstracts, but it also has many other very important applications and uses, which I will describe later. Right now, though, I'd like to tell you how to make a broken mirror and suggest ways you can use it to make abstracts.

Making a Good Usable Broken Mirror

With rubber cement, glue an 11" × 14" mirror on a piece of black cloth larger by four inches on three sides and eight inches on the top. The cloth should not be tautly stretched. After the rubber cement is thoroughly dried and the mirror and the cloth are firmly glued together, put a folded towel under the cloth and a layer of newspapers on top of the mirror and hit the mirror near the center with a hammer. You will get a spider-web design of cracks radiating out from where the glass was hit.

Staple the long side of the cloth to a stick; leave small pleats between the staples so that the broken mirror will have some flexibility. What you will have is a kind of flag. The long end of the stick can be attached to the horizontal bar of a light stand with masking tape or clamps, and the mirror (or the flag part) will hang down. I only have one such broken mirror. You, however, might want to have several. You could have a broken mirror that was hit in several places so that the web of broken lines would be jumbled. Or, you could make a designed broken mirror: With a glass cutter, you could place scratches on the mirror exactly where you want the breaks to occur, and then the mirror will break right at the scratches when you hit it.

With a broken mirror, you can focus:

1. on the surface of the mirror, the broken cuts creating a webbed pattern over the out-of-focus reflected colors or objects.

2. on the distorted jumbled reflection, losing the out-of-focus webbed pattern of the breaks.

3. in between the surface of the broken mirror and the reflection, just getting an indication of the webbed design of the breaks as an overlay on the reflection.

Before shooting, turn your focusing ring back and forth and study all the different effects. Remember, reflective materials will increase the range of possible abstracts.

USE OF GLASS DEVICES TO CREATE ABSTRACTS

Glass devices also change and distort the reality of the materials and objects you photograph. Like reflective surfaces, they can be used for subject matter other than abstracts, and that too will be explained later in the book. Glass devices are used anywhere from right in front of the lens to all the way up to the object being photographed. To use these devices, you could start off with any of the materials listed on page 28. You might, for example, set up a poster, since it is fairly large, or a large piece of printed fabric, and use the glass device to create unusual effects. Do not put the camera on a tripod because you should be free to move back and forth, playing with the different devices and trying several of them to see and experience the different results.

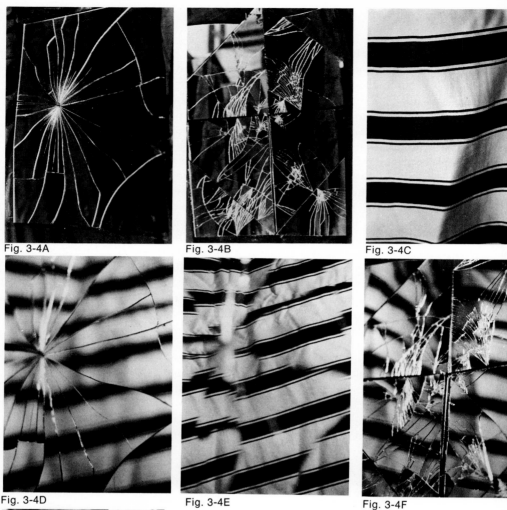

Fig. 3-4A

Fig. 3-4B

Fig. 3-4C

Fig. 3-4D

Fig. 3-4E

Fig. 3-4F

Fig. 3-4G

Fig. 3-4A is a mirror hit only once, resulting in a simple pattern of breaks. Fig. 3-4B is a mirror hit several times, resulting in a complicated pattern of breaks. Fig. 3-4C shows a black-and-white striped fabric, to be reflected in both types of broken mirror. In Fig. 3-4D the simple pattern of mirror cracks is in focus and the fabric stripes are out of focus. In Fig. 3-4E the simple pattern of cracks is out of focus, while the stripes are in focus. In Fig. 3-4F the complex pattern of breaks is in focus and the fabric is out of focus. In Fig. 3-4G the fabric is in focus, while the busy pattern of breaks is out of focus.

Glass Devices

1. Flat patterned glass
2. Window glass
3. Prisms
4. Cut-crystal or pressed-glass objects
5. Magnifying glass

1. *Flat Patterned Glass.* If you go to a glazier's shop, you will find all kinds of patterned glass, from very slightly patterned glass to busy, complicated patterns. Several pieces of this kind of glass, both large and small, are handy to have. To prevent cutting yourself when handling the glass, either sandpaper the edges or put cellophane or masking tape around the edges.

To work with a large piece of glass, set it up somewhere between the camera and the object you are photographing. I use a wooden chair, rest the glass on the seat, and hold the glass firmly upright by a clamp to one of the vertical slats of the chair. You could also place the glass in a picture frame and rest the frame and the glass on the chair. As I said earlier, these devices have applications in later work, so if you go to any trouble to get the materials and the setups, remember you will have additional uses for them.

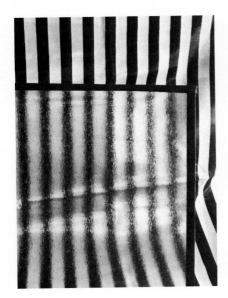 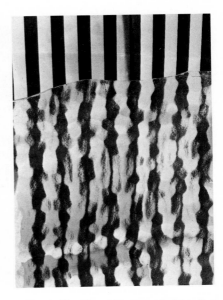

Fig. 3-5A. The effect created by flat, finely patterned glass.

Fig. 3-5B. The effect created by flat glass with a broader pattern.

35

If you want to start off with just a small piece of glass, you could simply hold it in your hand and move it back and forth in front of the lens.

2. *Window Glass.* If you have a large piece, you can paste all kinds of things on it—small pieces of colored cellophane, sequins, glass gems, and so on. Use it in the same way as the flat patterned glass.

3. *Prisms.* If you have a prism, hold it it front of the lens, and keep turning it around. You will see that it gives you rainbows on the highlights and edges of things, especially highly polished metal objects and crumpled foil. Be careful of your exposures when using a prism, as it lowers the light reading.

4. *Cut-Crystal and Pressed-Glass Objects.* These devices, moved back and forth and angled different ways in front of the lens, will do the same thing as a prism. The facets are in effect many prisms, so you will have jumbled and multiplied rainbows. Additionally, you will have all kinds of indefinable extra images.

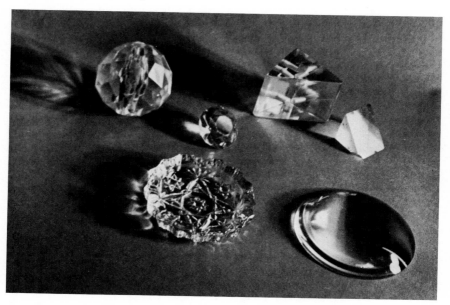

Fig. 3-6. Some of the devices that can be used in front of the lens—cut crystal, prisms, pressed glass, and a magnifying glass.

Automobile-headlight covers are discs of pressed glass with interesting designs. I found a large automobile-headlight cover with concentric circles crossed by lines going out from the center. I used it in front of the Christmas-tree lights and had an effective take II for a series I did on a girl and boy dancing, a shooting explained in Chapter 10.

5. *Magnifying Glass*. This has its own characteristics, which you will enjoy discovering. It diffuses the focus unevenly; and if you have some extra lights around while shooting, even ordinary ones like a ceiling light or a reading lamp, the magnifying lens will pick up highlighted spots. If you have an enlarger, take out one of the condensing lenses. They are in effect rather large magnifying lenses, and they can do some funny things.

All the foregoing information dealt exclusively with some ways and means to make abstracts in your studio, under controlled conditions. There is an endless source of material outside your studio waiting for you to come along with your camera and extract the abstracts. In the next chapter we'll examine some of these materials.

I don't believe there should be too many rules and regulations for making abstract slides. For your first couple of rolls, you should keep exposure charts; after that it's up to you whether or not you want to keep exposure records. All you really need are some suggestions, a few guideposts, and then you can just take off and discover your own way. Abstracts are highly personal means of expression, and after you get going on them, they almost begin to make themselves.

In making your way in this area, using the camera and all these various devices, techniques, and objects to create abstract transparencies of various types, you will discover at what point in the soft focus and at what point in the camera movement you find your truest expression. You will learn that if your focus is too sharp, you will get a slide that is not an abstract, but a dull picture of broken mirrors, sequins, pieces of paper, or whatever. You will realize that in creating abstracts, you can go from a wildly contrasty range of color to subtle variations of one or two colors. But, as you go along, working, trying this combined with that, somewhere you will find a whole range of your own.

4

Reflective Surfaces

MIRRORS

The use of mirrors and other reflective surfaces to distort and change the appearance of objects and thus create abstracts was introduced in the previous chapter. In this chapter we will discuss how mirrors can be used to emphasize—not distort—some of the characteristics of what is being photographed. Before we get down to specifics, I would like to digress and go into a general discussion of the connection between photography and mirrors.

Before the camera was invented, mirrors allowed people to view themselves in a way that closely approximated reality. But photographs offered people a new and better way of seeing themselves, as well as a new and better way of seeing other people, places, and things. Those very photographs that, when taken, were part of an existing reality, inevitably became part of history: Though people and their environment inexorably move forward, images on a photograph remain fixed. It is the permanence of the photographic image that gives it a broader dimension than a mirror image.

In art forms other than photography a limited use is made of the mirror. In literature, many references are made to the psychological aspect and the mystery of the mirror. The earliest reference I know of is in the Bible, the famous, "as through a mirror darkly." Shakespeare, in "Hamlet," compares the art of acting to the reflected image: "The purpose of playing, whose end both at the first, and now, was and is, to hold as 'twere, the mirror up to nature." In Lewis Carroll's *Alice's Adventures in Wonderland* and *Through the Looking Glass*, Alice actually steps into a mirror, as though it was an extension of her imagination, her

private fantasy, where the impossible becomes possible. We are also trying to use the mirror in an imaginative and fantastic way to extend the scope of our cameras.

In painting, the artist uses the mirror for a self-portrait. Ballet studios, where practice and rehearsals take place, invariably have a mirrored wall so the dancers can check and recheck their work. The mirror in effect splits the dancer into two people, so that he becomes both the performer and the viewer. Architects, in interior design, use mirrors to increase lighting and brilliance, as in the Hall of Mirrors in Versailles.

It is an eastern-European folkway to cover the mirrors in the house when someone in the family dies, because of the fear that the dead can come back out of the mirror to haunt the house—as though the mirror, like a photograph, is a repository of the past. A friend of mine, who comes from a small village in the southern part of China, says this custom is practiced there, too.

I feel that all this is pertinent to our work because I know you will find a great excitement when you uncover the untold number of variations offered by the mirrors and other reflective surfaces. I cannot place too much emphasis on the immense part reflections will play in creating and building up image impact in your slides and transparencies. By using mirrors and other reflective surfaces, we broaden the scope of the camera and in effect give it extra eyes to see with.

Use of Mirror in Photographic Situations

One basic use of the mirror in photography, easily overlooked, is that it doubles the distance of the reflected image to the camera. The photographer can stand practically side by side with a model in a small place, both of them facing a mirror. The photographer, the model, and the mirror can be thought of as standing at the three points of a triangle, and if the model-mirror-photographer angle were widened, like a folding ruler, the model would end up at one end and the photographer at the other, making a clear shot possible. Generally, however, when shooting into a mirror, the photographer can easily be reflected into the camera along with the model; he should either allow it to happen knowingly, or take care to avoid it. Also, the photographer must be aware that a mirror cuts down on his light reading (Fig. 4-1).

Another fact to consider is the influence of the mirror on the model. Something special happens when the model looks into the mirror. It releases the model's tension—the feeling of being a fish at the end of a line or a marionette—and makes her feel less at the mercy of the person with the camera. This feeling can be unnerving and uncomfortable. When looking into the mirror, the model's self-awareness is reinforced, and the relationship between the photographer and the model is

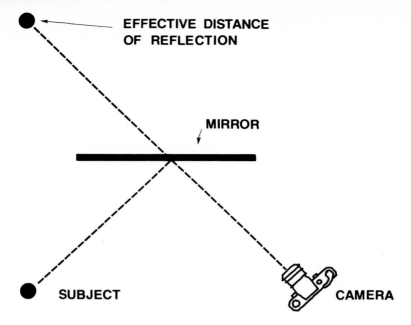

EFFECTIVE DISTANCE OF REFLECTION

MIRROR

SUBJECT

CAMERA

Fig. 4-1. When using a mirror to take pictures, it is important to remember that the effective photographer–model distance is greatly increased. This will not only change the point of focus, it will also cut down on the photographer's light reading.

equalized. It gives the model a freer feeling, and thus makes for a better working mood.

There are many different types of mirrors, each with its own characteristics; I'd like to deal with them here. I will also recount projects involving these different types of mirrors.

Types of Mirrors

 1. Small mirrors.

 2. Large mirrors.

 3. Broken mirrors.

 4. Convex mirrors.

 5. Mirror setups.

 6. Mirrors of designed and geometric cuts.

 1. *Small Mirrors.* You could take a small mirror, glue it on an opaque surface, on a design, on a painting, on a large poster, or on a photograph of a person or a scene, have someone's face reflected in the mirror, and then photograph the whole thing. The person's face has found a new environment, an environment that is totally under your control.

 I glued a small mirror on a board, and then glued rose-colored sequins all around the mirror (Fig. 4-2A). A girl's face was reflected in the mirror, and the sequins, which were out of focus, gave a shimmering effect; the face appeared to be floating in this indefinable pinkish sea (Fig. 4-2B). I did the same thing with crumpled foil paper. I'm sure you have seen many photographs, and shots in films, where faces are seen

reflected in the side-view and rear-view mirrors of a car. You can take advantage of small mirrors that one finds in stores, especially in cosmetic and millinery departments. Incidentally, once you are alerted to the possibilities of using certain things, it's amazing how you begin to find them in so many places (Plate 7).

2. *Large Mirrors.* If you have a large mirror, think in terms of pasting various things on the surface, either scattered or closely bunched together.

Some of the things to put on the surface of the mirror:

a. Small pieces of cellophane, clear or colored.
b. Stained glass.
c. Lace patterns.
d. Drawings made with grease pencils.
e. Colored sequins, or small pieces of gold, silver, or colored gilt paper.
f. Artificial flowers and leaves.
g. Translucent decals.

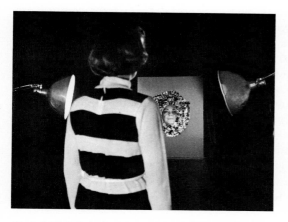 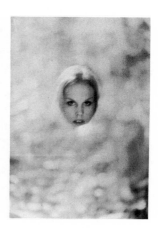

Figs. 4-2A & B. Left, the rose-colored sequins are pasted around the small mirror. The sequins *and* the face are lighted so that both will show up in the picture. Right, a black-and-white copy of a shot resulting from this setup. The model's face appears to be floating in a sea of blurs.

Again, I will not give specific detailed instructions, but general descriptions. Put any one of these items on the mirror, and use it in conjunction with one or two people. Study the overall effect through the camera in close-up, medium, and long shots. If you are working with two people, you might have one facing the camera, and the other one facing the mirror. Alter the distance of person to mirror, or photographer to mirror. Try different depths of focus and different lighting effects.

I will tell you about some of the things I have done with large mirrors that you can try. I took one mirror that was set in a gilt frame, pasted small irregularly shaped pieces of colored cellophane on it, and photographed a nude reflected in it. The nude was in focus, but parts of the body appeared to be out of focus or blurred because the pieces of cellophane upset the absolutely even focus. Another project of mine was to place artificial flowers—soft pink and yellow roses with green leaves —in front of a mirror. I had a face reflected in the mirror just above the flowers. The flowers were proportionately much larger than the girl's head which appeared to be emerging from the flowers. I had the focus in between the girl and the flowers, resulting in an overall soft focus.

You can do a take I of a person, and then do a take II of the same person reflected in a mirror. If you combine a person with his reflection, mix soft focus with sharp focus, and use different lighting effects, you can get a whole series of variations.

You can also get several mirrors and set them up at slightly different angles, or imitate the three-sided mirror setups in the fitting rooms of clothing stores.

3. *Broken Mirrors.* I paid at least six months' rent with earnings from work I produced using a broken mirror (directions for making it on page 33). A broken mirror does many things to a face. Again, invite your patient and loving friend to the studio and set up your broken mirror. If you look through your camera at the face reflected in the broken mirror, and just move around very slowly, you will see that the reflected face will go slightly out of kilter, then one or two features will become multiplied or fragmented, until finally the entire face will become torn apart and almost obliterated. Every 1/4" that you shift can give you a totally different distortion and composition. Try your close-up attachment on the lens; also try a wide-angle lens. Remember, you can, if you like, get the fragmented effect you want, without giving away the fact that you used a broken mirror, by focusing on the reflections. The lines of the breaks will then blur.

I made two similar photographs with the broken mirror, one of a woman's face and the other of a man's face. Both were closeups and double exposed on abstracts. Moving around with my camera, studying the reflections of the man and the woman, I found one point at which the cracks in the mirror caught the upper part of their faces and swept it up, multiplying the area of the eyes about six times. The impact of this distortion was such that the pictures expressed something that could be interpreted as fear, awe, or extreme puzzlement.

Once I had an assignment to photograph the work of Sabra Moore, a sculptress. She had one very arresting piece which she called "Mask-Woman"—a white distorted face, with large painted red lips and very realistic protruding artificial glass eyes, ringed by thick false eyelashes.

Even as it was, it was quite a shocker, but reflected in a broken mirror, with fragmented and multiplied features, the horror of it was intensified; in addition, it appeared to be reacting to something horrible. I also photographed "Mask-Woman" reflected in plastic material; this stretched the head lengthwise and made it undulate, with one eye coming forward in sharp focus and the rest of the face still discernable but slowly melting into out of focus, like one of Salvador Dali's soft watches (Fig. 4-4). I also double exposed this grotesque white face on an abstract, mainly to feed color into it.

In making a 22-minute slide-and-sound show of nearly 300 slides (see Chapter 11), I used many pictures of one man—his eye, his face, and his whole body as a line in and out of the different sections of the work. To show his changing moods and reactions, I used a large variety of mirrors, reflective surfaces, and other devices. I used the broken mirror more than any other device (Fig. 4-5).

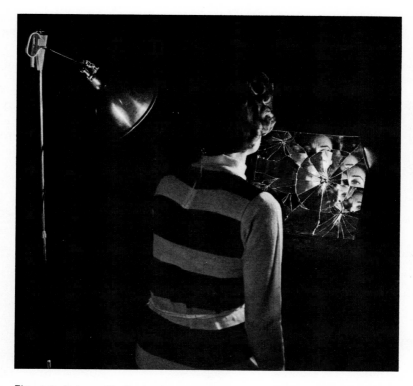

Fig. 4-3. Setup with the broken mirror, showing the fragmentation of the image.

In most of the slides I made with the broken mirror, I multiplied some of the man's features. One of these slides was particularly poignant. I had been double exposing on the hurly-burly, the garishly decorated movie houses of 42nd Street, the crowds of people moving and surging about. (I always feel that a subterranean impulse, a force outside themselves, propels these people about.) In all this activity, I miraculously got a perfectly aligned double exposure of my subject's sad fragmented face—one eye repeated three times on the same frame—and another man on crutches dragging himself down that crazy street in the middle of the throng (Fig. 4-6).

Slides made with the broken mirror seem to get at something deep within us, and bring to the surface something we all feel. It is as though the broken mirror reflects that which has gotten out of whack within us and in the world. This feeling of disjointedness is expressed in contemporary dance, theater, painting, sculpture, and especially in the jangling discordances of rock, jazz, and modern music.

If you become interested in the effects achieved with the broken mirror, you might want to have more than one. Start out with one and then decide what additional scope you need. You might want to have mirrors of different sizes, or some with more or fewer breaks in them.

Fig. 4-4, left, the "Mask-Woman" sculpture reflected in the broken mirror. Fig. 4-5, right, a picture from the slide show showing the man's fragmented face double exposed against a shot of the sun setting in the trees.

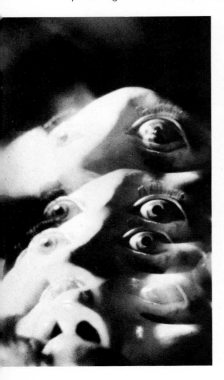 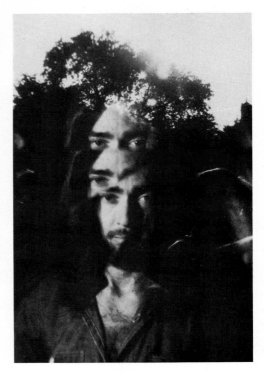

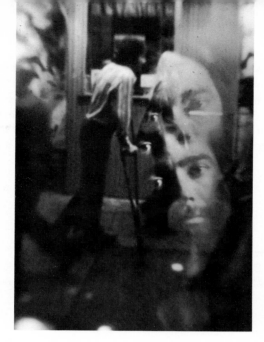

Fig. 4-6. Another shot from the slide show shows the man's fragmented face double exposed on a 42nd Street scene.

4. *Convex Mirrors.* I have never been able to do anything with concave mirrors, but you might want to try them. I like to work with convex mirrors, and have done many things with them. (Definition of convex: curved like the outside surface of a sphere. Definition of concave: curved like the inside surface of a sphere.) What follows is a description of two projects of mine that you might like to repeat.

I used convex mirrors on an assignment for a science-fiction book that had to do with cities that had been detached from the earth and were floating in space. I had noticed that trucks often have a convex mirror about four inches in diameter attached to the driver's side-view mirror, which gives him a wide-angle view of the road similar to the wide view you get with a wide-angle camera lens. You have also seen convex mirrors in stores and elevators. These mirrors can be purchased in any auto-accessory store for around $3. I bought four circular ones, and glued them on a 14" × 17" black illustration board (Fig. 4-7A).

With a "prepared" roll of film in the camera, I went to the roof of a building that had a good view of the skyline. I rested the board on a chair and photographed it, filling up the viewfinder with the whole of the black cardboard. The four convex mirrors reflected a view of the city. Beams from the sun bounced off the convex mirrors in sharp rays. Since it is hard to get a proper light reading off a convex mirror, the exposure bracketing was very wide: two stops both over and under the reading with half-stops in between. The focus was as sharp as possible, though it

is difficult to focus sharply on the image in a convex mirror. Although shooting outdoors, I used High Speed Ektachrome Film (Tungsten)—36 exposures—which is balanced for indoor shooting and goes to the blue side when used outdoors. I wanted a predominantly blue tonality, in order to reinforce the effect of outer space. I had planned to do my take II on "space" indoors. I created "space" by laying crumpled blue cel-

EXPOSURE CHART

Light Reading for Take I, Cities Reflected in Convex Mirrors, *f*/8 at 1/125 sec.
Light Reading for Take II, In-studio "Sky," *f*/5.6 at 1/60 sec.

Frame #	Take I		Take II		Frame #	Take I		Take II	
1	f/8	1/125	f/5.6	1/60	19	f/8	1/125	f/4	1/60
2	f/8	"	f/4-5.6	"	20	f/8	"	f/4-5.6	"
3	f/8-11	"	f/4	"	21	f/8	"	f/5.6	"
4	f/11	"	f/2.8-4	"	22	f/8-11	"	f/5.6-8	"
5	f/11-16	"	f/2.8	"	23	f/11	"	f/8	"
6	f/16	"	f/2.8-4	"	24	f/11-16	"	f/8-11	"
7	f/11-16	"	f/4	"	25	f/16	"	f/11	"
8	f/11	"	f/4-5.6	"	26	f/11-16	"	f/8-11	"
9	f/8-11	"	f/5.6	"	27	f/11	"	f/8	"
10	f/8	"	f/5.6-8	"	28	f/8-11	"	f/5.6-8	"
11	f/8	"	f/8	"	29	f/8	"	f/5.6	"
12	f/5.6-8	"	f/8-11	"	30	f/8	"	f/5.6	"
13	f/5.6	"	f/11	"	31	f/5.6-8	"	f/4-5.6	"
14	f/4-5.6	"	f/8-11	"	32	f/5.6	"	f/4	"
15	f/4	"	f/8	"	33	f/5.6	"	f/2.8-4	"
16	f/4-5.6	"	f/5.6-8	"	34	f/4-5.6	"	f/2.8	"
17	f/5.6	"	f/5.6	"	35	f/4	"	f/5.6	"
18	f/5.6-8	"	f/4-5.6	"	36	f/4-5.6	"	f/8	"

46

lophane on top of blue paper, lighted from the side for highlights. I didn't use the real sky because the city sky isn't blue enough, and even in the country I might not have been able to get the exact shade of blue I wanted when I was ready to shoot. By using blue cellophane and blue paper, I could get a strong shade of blue. The exposure bracketing for the "sky" was not as wide as for the "cities," but I shot with variations in the focusing.

The effect that these were cities whirling through space was enhanced in the slides, where the exposure of the "cities" was strong and the "sky" was semi-out-of-focus and slightly overexposed. The "sky" filled up the unexposed area of the black cardboard and spilled over sufficiently into the reflections of the "cities" to blur the outline of the convex mirrors (Fig. 4-7B)

If you study the chart you can see that I tried to get as many different combinations of exposures as I could on a 36-exposure roll. If you start with your basic light reading, and you have some idea of the image you wish to capture in your photograph, you usually get a result if you take care of covering all the technical aspects. Sometimes the results can be even better than anticipated.

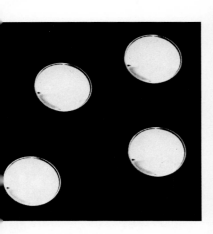

Fig. 4-7A. Four convex mirrors mounted on a black board.

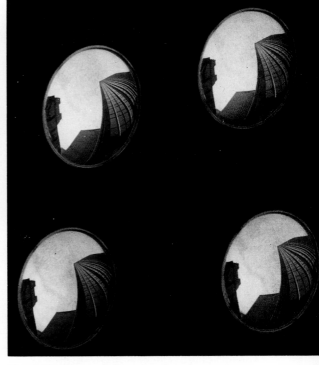

Fig. 4-7B. The same four convex mirrors with reflections of city buildings and the sky.

After the success of the "cities in space" project, I wanted to continue working with convex mirrors just for my own pleasure. I took a convex rectangular mirror with rounded corners that was approximately 5″ × 7″, and I mounted it on a black cardboard. A friend came with me and held the mirror. We walked on Wall Street, on Park Avenue in the fifties and on the Avenue of the Americas from 50th to 55th Streets. She held the board out like a tray, tilting it when necessary, and I bent down and photographed the skyscrapers reflected in the convex mirror. The reflections curved in from wide bases to very narrow, almost pointed, tops (Fig. 4-8). I also photographed traffic and people coming down the street. It was like having a cheap fisheye lens. And with the mirror you have the added possibility of tilting to experiment with. For this series of pictures, I used Daylight Ektachrome film, black-and-white film, and infrared color film. The infrared made the city a rosy, pinkish, pretty place. I double exposed about a quarter of the roll, but in this case double exposing did not enhance the subject and the single takes were better.

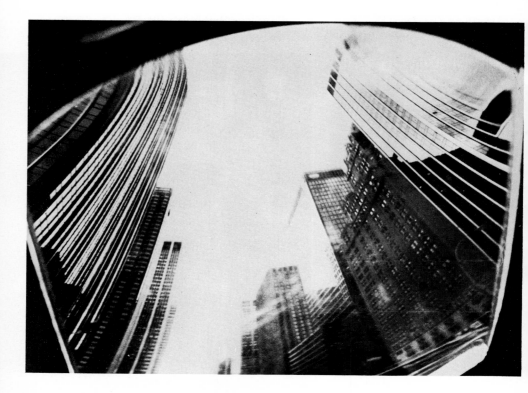

Fig. 4-8. The rectangular convex mirror reflecting the tops of tall city buildings on the Avenue of the Americas in New York City.

5. *Mirror Setups*. Mirrors reflect what is, but several mirrors, placed at angles to each other, will reflect the reflections, *ad infinitum*, and take us right out of reality into endlessness.

I used three 11″ × 14″ mirrors to produce a cover for two science-fiction book covers dealing with timelessness. I placed one mirror on the top of a table and made a tent-like structure with the other two mirrors, holding them together with Scotch tape.

One of the books for which I created this setup was about a new species of "man" that lived in timelessness. I found a small tin wind-up toy in the 5 & 10, with a large head, no neck, an oval chest, very thin arms, and long heavy legs. I altered it slightly by bending the arms, and hung it by a thread from the center of the "infinity" tent. I gave the little man suspended inside the tent an environment of colored sequins, broken glass, small pieces of mirror, prisms, pieces of faceted pressed glass, glass doorknobs, marbles, and pieces of foil paper. I also put some crumpled cellophane, in all colors, on the mirrored floor and pasted some on the mirrored walls (Fig. 4-9). Everything was reflected back and forth from one mirrored surface to the other like an eternally resounding echo.

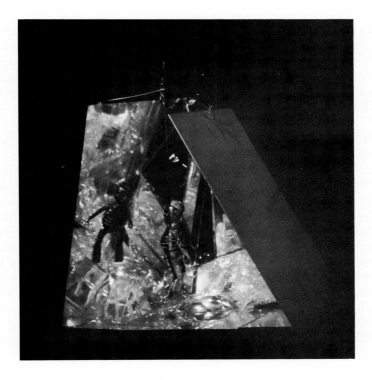

Fig. 4-9. The "infinity tent" setup.

49

I threw a spotlight on this setup and kept studying all the different compositions created by just bringing any one of the many different reflections into focus backed and fronted by vague, similar, out-of-focus reflections. It was important to make sure I had a very shallow depth of field so that I could suggest a new kind of reality without at the same time revealing the actual fact of what I was shooting. Take II was crumpled red foil paper, out of focus, to fill in all the shadow and dark areas with an atmosphere of "flames."

I don't expect you to follow my shootings step by step, though you can if you want to. I just want to present you with some examples of what I do in order to impart some of my experiences and perhaps help you to go on and do your own thing.

For the cover of the second book, which was about spheres whirling through endless space, I replaced the "man" in the "infinity tent" with a crystal ball about the size of a baseball. It had been given to me by a neighbor who had bought it in Atlantic City. The crystal ball, representing the sphere, rested inside the mirrored tent surrounded by all the appurtenances of an outer space environment: the crumpled cellophane, the sequins, the broken glass, and the foil paper. The color was predominantly blue. The bubbles inside the crystal ball picked up odd specks of color. When I looked through the viewfinder and manipulated the focus, my structure became an endless, timeless universe even to me, despite the fact that I had just put the whole thing together and knew it was sitting on top of a table in my studio. People outside photography don't know that you experience one of the most thrilling feelings when you look through the viewfinder and things fall into place the way you want.

This tent of mirrors, with its multiplicity of reflections, projected a negation of gravity and a feeling of weightlessness, which is what I think we mostly associate with outer space. It is thought-provoking that something so foreign to the human experience like weightlessness should be so universally understood. I guess we all have experienced it in our dreams, in our subconscious, and perhaps in a former life. Although weightlessness doesn't exist for us, we all seem to have a sense of what it is, and we all seem to yearn for it. At times I get a sense of what weightlessness is from music, a circus aerialist, or from a gliding bird.

As I write all this, I realize that the camera can give you the power to take something small, ordinary, and insignificant and turn it into something vast and extraordinary.

6. *Mirrors of Designed and Geometric Cuts.* In window displays I had noticed mirrors made of little squares like graph paper, and by inquiring I discovered Parallel Manufacturing Corporation, in New York City. This firm specializes in cloth-backed cut mirrors, which it calls *Paraflex.* Paraflex comes in square cuts, parallel cuts, and diamond-shaped cuts,

and as the name indicates, it is flexible. I specifically sought out this company because I wanted a square tube and a six-sided tube mirrored on the inside to fit over my lens and extend out from it. Parallel makes products for window displays, interior decorating, lamp bases, picture frames, novelty boxes, and so on. The company also does custom work for photographers, and will make specially cut sheets and mirrored tubes. I got the idea for the home-made cloth-backed broken mirrors from Paraflex. I bought several sheets of the following: $1/2''$ square cuts, $1''$ square cuts, $1/2''$ parallel cuts, $1''$ parallel cuts, and $1^1/2''$ parallel cuts.

I cut through the cloth backing of the parallel-cut mirrors and fit the long slender pieces of mirror inside a square tube. This fit over the lens and was large enough to extend back to the body of the camera; it bounced the image back and forth and exploded it out from the center. In the picture, the model is in the center, unreflected, surrounded by a burst of repeated reflections. The tubes I made were 14" and 16" long. I wanted to stay fairly far away from the model so that her face in the center would be small and I would have plenty of film area for the burst of reflections (Fig. 4-10). You could make progressively shorter tubes allowing yourself to get closer to the model, have a larger image, and fewer reflections.

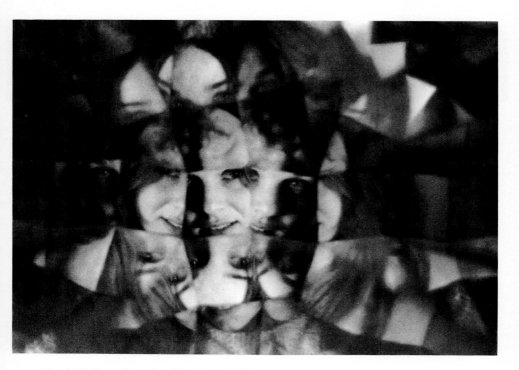

Fig. 4-10. Portrait made with mirrored tube.

One of the characteristics of these cloth-backed mirrors is that if they are absolutely flat only a small amount of distortion occurs, and if you have extreme depth of field your reflected image as well as the geometric cuts on the mirror will be sharp. Therefore, you can get an image with a clear-cut overlaid design. As the depth of field shrinks, you can either bring the reflection into focus and have the mirror-cuts design hazy over the image, or you can do the reverse, and have sharp geometric cuts over a hazy image. You can also let your focus waver in between, and have both the image and the cuts in equally soft focus. You have these choices and can achieve whatever suits your purpose best (Fig. 4-11).

 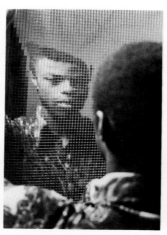 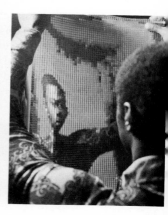

Fig. 4-11A. Straightforward portrait of a man.

Fig. 4-11B. Portrait of same man reflected in a flat sheet of Paraflex, showing just a little distortion.

Fig. 4-11C. The man curves the sheet of Paraflex; his reflection is much more distorted.

However, as soon as this cloth-backed cut mirror is just slightly off a level plane, everything reflected in it goes askew, and the cut edges give off all kinds of glints and highlights. I took the sheet of 1" parallel cuts, 11" x 14", stood it up, backed it by a board, held it upright with a small clamp in the center, and let the two sides gently curve out to form a concave arc. A girl's face reflected in it became broadened, and one slender vertical area of the face, including one eye, got picked up in the curve and was repeated over and over horizontally.

I was given an assignment to make a transparency for an electric company poster intended to stimulate interest in air conditioners. The art director wanted a photograph which would fit the copy line "Cool Jazz." I photographed a trumpet lying on top of a mirror of ½" square cuts.

There was a slight distortion, and I felt it looked as if the trumpet was lying on top of ice cubes. I did another take of the trumpet lying on a piece of plain glass, surrounded by real ice cubes. There was a light underneath the glass and one over the trumpet. This was the picture they used for the poster. I felt that the first picture where the Paraflex was used looked more like ice cubes and was a better illustration of the copy line "Cool Jazz."

This is not entirely relevant, but as we come to the end of this section on mirrors I'd like to quote a few lines from *Seven Arrows* by Hyemeyohsts Storm, a book about American Indians published by Harper & Row: "The Medicine Wheel can best be understood if you think of it as a mirror in which everything is reflected. . . . Any idea, person or object can be a Medicine Wheel, a mirror for man. The tiniest flower can be such a mirror, as can a wolf, a story, a touch, a religion or a mountain top. . . ." With all respect to the tradition of the American Indians, I should like to add "a photograph" to that list. The book goes on to say: "But it is only man of all the beings on the Wheel who is a determiner. . . ."

The thinking expressed in these quotations reinforces my belief that the work we do is of great importance because it is a reflection of ourselves.

PLASTICS

We are now going to examine the reflective characteristics of different plastics and metals. Neither the plastics nor the metals reflect shapes and colors as faithfully as the straight, flat, silver-backed glass, the mirror. It is these very so-called shortcomings, however, that we use in our work. In this section we'll deal with the plastic reflective surfaces, and in the next, the metals.

Plastic reflectors vary from being as rigid as glass mirrors to being softer than fabric. Also, these mirror-like plastics are available in many colors. Sequins, whirling streamers, funny mirrors, and innumerable other things are made of these materials.

A rule you could follow is: The stiffer the plastic material, the truer the reflected image, and the softer the plastic, the more distorted the image. I do not like the extreme way soft plastics distort reflections of people, objects, interiors, or exteriors, although I have seen some wonderful color slides made by other photographers who used soft plastics. I reserve the soft-plastic reflectors for making abstracts, or for backgrounds, where they work wonderfully.

My favorite stiff plastic is a silver polystyrene of .010" thickness. I got several 21" × 40" sheets from Coating Products, Inc., of Englewood

Cliffs, New Jersey. I used them over and over again. I still have a few of them: Even old, battered, and scratched, they're great, and they do all kinds of special things for me.

When hung like curtains, the stiffer plastics will be almost flat or very slightly curved. The softer plastics can be softly draped. If you touch or hit either one of them, you get a nervous, quivering shimmer, so that light glances off them as it does off water. If you crease or bend the polystyrene, or fold the mylar, you get lines of strong, glinting highlights at the creases.

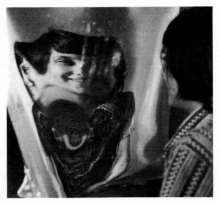

Fig. 4-12A. The polystyrene hangs in front of the model, the photographer is behind the model. The reflection is not too distorted.

Fig. 4-12B. Here the model bends the sides of the polystyrene sheet, increasing the distortion.

Fig. 4-12C. This is an enlargement of the face in Fig. 4-12B. Note the distortion in the design of the model's shirt.

54

Another unique characteristic of plastic reflectors is that you can increase or decrease their distorting qualities by moving around and changing the angle from which you shoot. The distortion increases as the angle from which you shoot becomes more oblique. Why this is so, I do not know; but it is something you will enjoy discovering and playing with.

Now I'll describe several things I have done—and you can do—with this material using both the 50mm and 35mm lenses, and close-up attachments. I hung a piece of polystyrene from the horizontal bar of my light stand with masking tape. This is a convenient way of working with the polystyrene because it can be easily raised, lowered, or rotated to a convenient height and angle.

1. A simple but effective group of pictures I did using the hanging polystyrene and a black background was to have a model reach forward with his hand just short of touching the surface of the plastic. His hand was greatly enlarged, his face was slightly distorted, and he seemed to be trying to ward off something. I double exposed this on several things:

 a. a large eye from a poster print, also reflected (Fig. 4-13).

 b. a simple, calm, unreflected portrait of the same model.

 c. abstracts (when in doubt, use abstracts).

Fig. 4-13. Double exposure of the man reflected in polystyrene and a poster.

2. On an assignment to photograph a cover for a book about three men involved in mysterious dealings, I positioned one man standing, another sitting in a chair, and the third sitting on the floor, all facing the plastic reflector. I did not plan to do a second take on this roll, so I placed one of my lights so that it was also reflected from an angle, with rays of light glancing off the surface of the reflector and filling up part of the background.

While shooting, I varied the degree of distortion by moving and changing my angle, but not to the degree that the identity of the subject matter was lost. As the angle changed, the light beams bouncing off the reflector changed, and in some pictures the men appeared to be standing in the blast of a searchlight.

3. I did something similar with just a man's head in a project for a science-fiction book cover. I used infrared film, and kept changing my angle to vary the distortion to a greater degree than in the previous shooting. Because of the film, which caused the face to be green, and the variety of distortions, I had a wide selection from which to choose my cover. In one transparency, the man's eyes ran together in a horizontal line across his face. I did some take II's on Christmas-tree lights that were reflected off an old, creased, scratched, and torn piece of polystyrene in a wild, lightening-like pattern. The infrared film definitely increased the eerie feeling not only because it made the face green, but also because it made the colors of the lights go all off, especially the reds, which went acid-yellow.

I was so entranced by this torn, scratched, and creased piece of polystyrene that I decided to try additional pictures with it, of this same man and for the same project. It was to be one take. I had the man's face reflected in one small area that was fairly smooth, and behind him the many Christmas lights were picked up by the creases and the bends, and the colors slid around like watercolor washes.

4. The word "mystery" connotes something unexplained, unknown, secret, or covered. To represent this concept visually, people are often made to wear their coats and hats. For photographs, side lighting is often used to create big pockets of shadow. A classic example of this kind of mystery image is the man in the trench coat. This type of thing is exactly what I did for a murder-mystery book cover. I had a man, and a woman in front of him, reflected in polystyrene. They were wearing their coats. This was a long shot. There was strong sidelighting to outline them and get a small amount of detail. They appeared to have just stepped out of darkness. The models were themselves fascinated by their reflections and were peering intensely at what they looked like in this setup. These few elements created the right mood for the mystery-book illustration (Fig. 4-14).

5. For the beginning sequence of the slide show I wanted to show the central character, the man, emerging from the mists at the creation.

Fig. 4-14. The mystery shot.

Again, I used a small piece of polystyrene as a reflective surface. The model was lying on a sofa, covered by a black cloth, so that he would be surrounded by black and be in a comfortable position, with the upper part of his body and his head held upright and still. This shooting would last long, and it was important that the model remain immobile. The lights were placed on each side of him, illuminating his face. An assistant stood to the left of the model and held the piece of polystyrene in front of the model's face; I stood behind the model's right shoulder and aimed the camera at the model's reflection in the polystyrene. The assistant bent and curved the polystyrene while I watched through the viewfinder until the reflection matched the effect I wanted. I used outdoor color film in order to get a red cast, which is what happens when it is used with tungsten lighting. I felt a reddish tone would help create the impression

that the man was emerging from the warmth or the womb of creation. In some shots, because of the curve of the polystyrene, one side of his face was stretched out to one side until it was a blur. In another shot his forehead was lifted and stretched up into a blur. In the final slide of this "emerging, forming" series, the model held the reflector himself, the way people wanting a sunburn will hold an aluminum reflector to their faces—in a wide arc going from the chin to the ears.

With the model lying back on the sofa as he held the reflector, I got up on a chair and stood right over him. With a wide-angle lens on the camera, I got a slide of a circular composition that included the model's real face and five reflections of his face spiraling around with the chins toward the center. The reflections were not too distorted.

6. A large funnel made of polystyrene, about 15" long, was used for this next shot. The small end measured 1$^{1}/_{2}$" in diameter, and the large end about 12". I intended to use this funnel to isolate the model's eye. It was very simple to make. I rolled the funnel and taped it. The model held it in position, and I adjusted it a few times, trying it out by looking through its large opening with the camera. Only his eye was to show through the small end. The other end had to be large enough so that nothing outside of it would be included in the frame and so that light could come through it without being blocked by my head. With the small end not quite touching the model's face, I managed to get some light on his eye from the side. The transparency showed an eye surrounded with a swirl of light spiraling from the edge of the slide, with the light swirls getting smaller as they traveled down the inside of the funnel to the center, where the eye was (Fig. 4-15).

I used a similar funnel, shaped like a teardrop, to isolate and contain a city view for a photograph made from a rooftop. I made the funnel out of black paper. With it the effect was different. No swirling light, but rather a center subject surrounded by opaqueness on which you could double expose (Fig. 4-16).

METALS

If you look in the history books you will find that in ancient times the first mirrors were made of metal. These metal mirrors were very much like ferrotype tins, which are highly polished, smooth, stainless-steel plates. They are used by photographers to dry black-and-white prints and give them a glossy finish. I happen to have several of these ferrotype tins, 10" × 14". I used them as reflectors to work out specific problems. For example, I took six of them and hung them vertically, overlapping slightly and not matching the edges. I rolled up long pieces of masking tape into balls, adhesive side out, and connected the tins to a background; by varying the thickness of these tape balls, I formed a concave curve with the tins, like the inside of a bay window. When I had to do a

 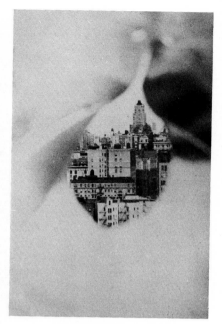

Fig. 4-15. The eye in the polystyrene fun-
nel.

Fig. 4-16. The city inside a teardrop-
shaped funnel.

color illustration representing a large crowd of revolutionaries, with
elements derived from documentary photographs to simulate realism, I
got three people into the studio and posed them with prop guns and
menacing expressions. The six ferrotype tins, put together in a concave
curve, multiplied these three people into a crowd of revolutionaries.

Use of Shiny Metal Objects

The reflective surfaces discussed earlier could reflect images in
various degrees of faithfulness, retaining some resemblance to the
original image. But in the reflections picked up by shiny metal objects
(unless these objects are fairly flat), the original image pattern is
completely lost, and only the lights and the colors survive the trip around
the bends, curves, and angles of the reflecting shapes. This reflection is a
brand-new entity that can be permanently sustained only in a photo-
graph. By using soft focus, and placing these metal objects in a
surrounding that alters their real dimensions and their original identity,
you can transform, for example, kitchen utensils and auto accessories
into supersonic vehicles and planets in the galaxy. Here, again, we use
the camera not for reporting what is, but for revealing what can be. The
few examples I'm going to give you are but a minute portion of the vast
possibilities awaiting you.

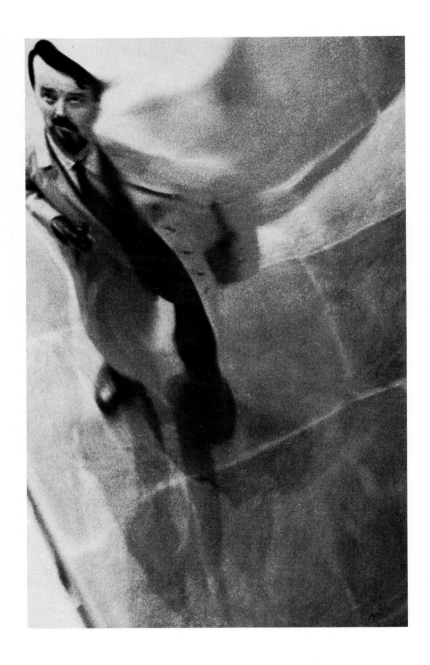

Fig. 4-17. A man reflected in a metal sculpture that was hanging from the museum ceiling. He was looking up at the sculpture when I took the shot; I had to be careful not to appear in the picture with him.

Making a Flying Saucer

I cut a circle of aluminum foil about 5″ in diameter and scattered sequins on it, to simulate flashing lights. I placed it on a piece of black paper, about one-third down from the top, and tilted the camera so that the aluminum disc would be elliptical. This was take I. I shot it in focus, out of focus, and at slow speeds from 1/15 sec. to 1 second. I wanted the effect of a disc-like object moving at a high velocity through space.

When I finished shooting, I had a nagging feeling that the picture wasn't going to look right. So, without waiting to see the results, I decided to use another object. I bought a small aluminum funnel, the type usually found in the kitchen. I did not put sequins on it. I placed it on the same black background and spot as the previous object, and shot it exactly the same way, with the same aperture and speed settings. It was lighted from one side. (In this take I, a dark blue instead of a black background could have been used to reinforce the color of the sky in take II.)

I was very lucky: When I finished shooting the aluminum funnel, it was the right time of the day for take II. It was that fleeting time between day and night when the sky is still a rich color, though it is getting dark, and some of the windows in tall buildings are lighted. While photographing, I was very careful to make sure that the tops of the buildings came up no higher than the middle of the frame, so that the aluminum funnel, or the flying saucer, would be in the sky. I did some take II's of trees and sky. For these take II's, I went up and down in the exposures, varying both the apertures and the time settings, and I moved the camera during the slow speeds. The pictures were a success. I was correct in anticipating that the aluminum disc with the sequins would be wrong. It was no "flying saucer," it merely looked like a Christmas decoration hanging incongruously in the sky. However, the aluminum funnel was right. Somehow, the three-dimensional shape caught the light correctly, and those takes with a slight movement in both the city and the funnel truly resembled a massive flying saucer racing across the sky above the city (Fig. 4-18).

This is another example where one can put unlikely things together with multiple takes, juggle their relative sizes, and produce a vast scene out of the ordinary and the small.

Creating A Galaxy

In the section on mirrored setups, I mentioned using a glass sphere in a mirrored tent setup to create a slide that would convey a feeling of timelessness. I got a similar assignment, and I decided to try to do something that would picture the traffic of futuristic vehicles moving through a galaxy in space. It is a challenge to try to create the impression of the vastness of the universe on a 35mm color slide.

The items with which I decided to build this galaxy were a flattened pie pan, car side-view mirrors, and scattered pieces of aluminum foil, to represent the moon, the space vehicles, and the stars.

Fig. 4-18. The flying saucer.

For a long time I have been intrigued by the shapes of highly polished, cast stainless-steel auto accessories. I really believe that the designers of these objects are artists. They manage to come up with such a tremendous variety of shapes, without losing sight of the functions of these objects. As small parts of the cars, you hardly notice them, but separated and on display in a store they can be seen for what they really are. I have often gone into stores to admire these objects. Blown up to gargantuan sizes, they would look great in any show of modern metal sculpture.

Anyway, I finally had a reason to buy some, and so I purchased three side-view mirrors, one oval, one rectangular, and one round. I put them on a royal blue background. Around them, I scattered bits of crumpled aluminum foil in star-like shapes. The flattened pie pan, which would be the moon, was much larger than the other objects, and I planned to include only part of it in the side of the frame. I varied my exposure and time settings. For some of the shots I held a prism in front of the lens, to break up the spectrum and put color on the highlights.

There are, of course, other uses for reflective surfaces, but as they involve other techniques, they will be presented in the chapters where these other techniques are featured.

As I write this and recall and review my work, I remember, even feel, the excitement I felt so many times, finding solutions to problems and first seeing results. I try to put myself in your place and predict what you will be doing as a result of reading this book. I'm sure it will be new and interesting and quite different from what I have done. I know that you will come up with ideas that I never thought of. I anticipate your excitement, your successes, and your frustrations. I sincerely hope that you will absorb as much information as possible, because everything in this book is based on experience. I hope that your successes will outweigh your misses.

As you work, you will get more and more familiar with your tools and your materials. With them, and with the techniques and devices I have mentioned, you will be able to uncover the peculiarities, the characteristics, and the spirit of what you will be photographing.

Fig. 5-1. Trees reflected in the surface of a pond.

5
Found Things

We have been inside the studio long enough, so let's take the camera and go outside. Out there is a rich treasure trove waiting for you—things that you can capture and make your own with the camera. As you walk around, the camera heightens your sensitivities, and you become like a hunter stalking prey, looking up and down and all around, never knowing when you will discover the very thing you need or want.

When you go out, you might also take along a few devices: cellophane, a prism, a magnifying glass, or a black or plastic funnel, anything to help you externalize some inner concept and to manipulate whatever it is that you accidently find, or specifically seek.

Since this is the first time we are deliberately going outside, you should be aware that there are two main categories of color film pertinent to our work. One is balanced for shooting indoors with tungsten lighting, and the other for shooting outdoors with natural lighting. Packed with each roll of film is a data sheet containing important information, such as ASA ratings, conversion filters, and so on. It is possible that, when double exposing, you would do one take indoors and the other outdoors. Because of this, you should know about conversion filters in order to realign the color balance, if you shoot with one roll of film in the two different light situations.

Outdoor film, used indoors, will have a reddish cast. Indoor film, used outdoors, will have a blueish cast. This is true of the Kodak Ektachrome films, and of the other films from which you get color transparencies. But please take the precaution of checking whatever film you may be using before photographing with it.

It is, of course, possible that you may want to exploit the quality of the incorrect color balance, in which case you would not use conversion filters.

How does one enumerate all the places in the world a photographer can work in? I'll limit this interminable list to my favorite places. Besides making use of the obvious country and city scenery, I've haunted art galleries, museums, artist's studios, dance and theater rehearsal halls. Wherever and whenever permitted, I have taken pictures. Following are some of the things I have found outside and photographed.

NEON LIGHTS

I especially like eye-level neon lights in store windows, because you can get as close to them as you wish. The light readings on neon lights are high, and here again, you might use the "two-finger" technique in front of the lens (see Chapter 3). You will discover as you look through the lens that the spread fingers, in addition to reducing the amount of light entering the lens, create an optical effect that changes the kind of design the neon lights create on the film. Be sure you shoot this out of focus, or at a slow speed with a moving camera (Plate 8).

STAINLESS STEEL ON BUILDINGS

This material is used for store fronts, entranceways, and trimmings, especially on new buildings. A blatant neon sign, reflected in a stainless-steel doorway, was metamorphosed, and the doorway became a brilliantly colored abstract painting. For some reason, it reminded me of a giant butterfly. I went back to the doorway time and time again, making many different abstracts; I also used it for take II's on faces, silhouettes, and dancers. I was sad when the building was torn down, and this combination of a sign reflected in a doorway one-half block away no longer existed. I once saw a brand new stainless-steel truck slowly move down a street, reflecting the store windows, signs, and the people, and becoming a glorious block-long ever-changing abstract painting.

WINDOW DISPLAYS

Department stores and specialty shops often have very talented and imaginative people creating their window displays. I favor jewelry store windows. I have often stood in front of them with my camera, twisting and turning the focusing ring. You will gasp at the beauty of the changes in the colors of the gems, especially diamonds, when you look at them in this way through your viewfinder. Such window displays have given me many ideas for new devices, new types of reflective materials, and they've also suggested ingenious ways in which to use them. Window designers understand how to use lighting in many interesting ways. It can be quite a stimulating visual experience to walk on Fifth Avenue, or any comparable street, and look through your camera. A commonly seen but interesting shot can be taken by photographing people who are

looking at a window display; in the photograph they will appear reflected next to what they are looking at.

When one prowls the streets with one's camera, sometimes nothing happens, and at other times totally unforeseen fortuitous events take place. I was walking along a street one day and happened to look up at a store window and saw on the window what seemed to be an apparition. I analyzed it and realized that a pigeon had flown against the window and left a mark of dust that resembled a fantasy bird. I quickly went inside the store, and found that the sun was hitting this dust mark so that it was brightly lighted. And to really finish off this string of lucky combinations, there was a dark building that happened to be behind the mark, setting it off with a contrasting background. A dust mark and all these circumstances created a new creature (Fig. 5-2).

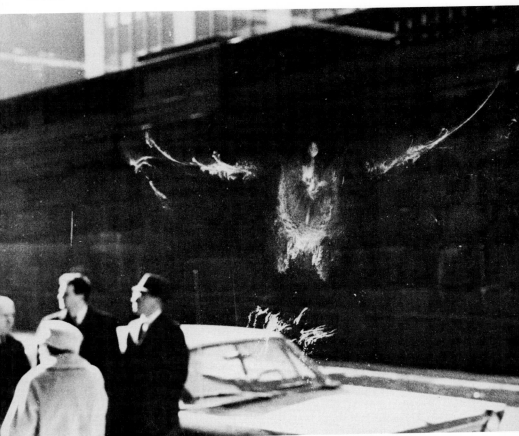

Fig. 5-2. The pigeon specter.

USE OF MIRRORS OUTDOORS

I saw a mirrored sphere in the window of an optical store. The mirror was not Paraflex but a most remarkable solid piece of mirror. It allowed me to capture a part of the window, myself, the whole street behind me, and the sky, all in one photograph. Almost all stores and elevators have convex mirrors in them that give you remarkable views. I once saw a convex mirror on the side of a building outside a bank teller's window; it enabled him to see people coming down the street. It reminded me of a sideways periscope. In Glasgow, Scotland, you will see long narrow mirrors at right angles to every window in an office building. The purpose of these mirrors is to reflect light into the windows. I have found beautiful rose-tinted or purple mirrors in movie-house entrances, some with gold veins in them in imitation of marble, out of which I made abstract take II's. I used one such mirror for a slide I did of the lighted tower of the Empire State Building at night, thus turning the night sky into a purple and gold sky.

A friend of mine took a picture through the window of a luncheonette, and because of a mirrored post inside, but very close to, the window, he got a photograph of what was in front of him and what was behind him: the people eating inside, the people in the street, and the buildings and the traffic behind him. It was as though he and the camera had vision in two directions.

GENERAL REFLECTIONS

At certain times of the day the sun's rays will bounce off windows and the metal trims and edges of buildings. In certain lights, the curved windshields of automobiles will show a bent and curved reflection of buildings and the sky, or an expanse of trees. If you're on a picnic, and you've just finished your salad and the sun is high and bright, the sun's rays will bounce off the thin layer of the left-over salad dressing like a thousand sparkling lights, and it will seem as though you're holding a dish of a thousand tiny diamonds.

RAIN

Rain will do such wonderful work for you. It will turn a dark forest into a place with a million little sparkling white lights as each little wet leaf catches a piece of the sky. Wet streets at night become wild abstract paintings, especially where there are many varicolored and bright lights. During the day puddles refract the sun's rays and turn them into piercing streaks of light, and you can find buildings, trees, the sky, and you reflected in them. Raindrops on automobile windshields become a multitude of small convex reflecting surfaces. They pick up the changing traffic lights, and as the car moves, these raindrops change from

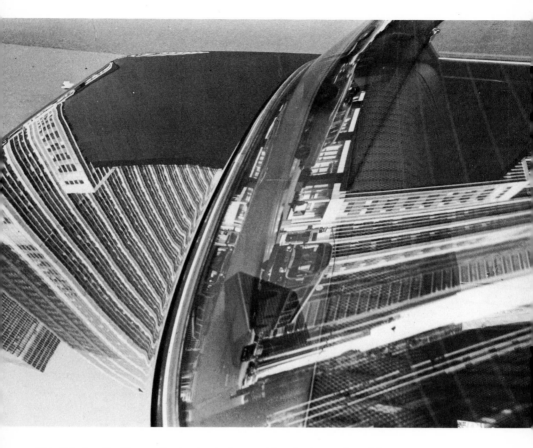

Fig. 5-3. A reflection on the back window and trunk of an automobile.

emeralds to rubies to yellow and white gems. Rain gives you a windshield that is a piece of patterned glass. During a rain, I have taken my camera, gotten into a cab, and driven a few blocks down Broadway just to take pictures through the windshield. You should also observe what raindrops and rain do to the highly polished bodies of automobiles.

The Museum of Contemporary Crafts, on West 53rd Street in New York City, once had a participation show. People were asked to bring to the museum things they found in the street—pieces of paper, boxes, bottles, and so on—or written impressions of what they saw, drawings,

or photographs. On my way to the museum, I was looking all around, and as I turned the corner from Fifth Avenue into 53rd Street, I noticed that the sidewalk along St. Thomas' was not concrete, but black slate; and a brief rain had changed the sidewalk into a shiny mirror. I found myself walking on a bright blue sky, on white clouds, and on trees. I was so sensitized that I felt intensely that something magical had happened and I slowed down; it almost pained me to take a step because I felt I was committing a desecration by putting my feet on the sky. I had probably walked on that particular sidewalk a thousand times and had never noticed its special quality before. But because of the challenge presented by the museum, my awareness level was way up.

This is the kind of "seeing" to develop for photography, and as you develop it you will begin to attain a mastery of technique. Coordination of penetrating seeing, or supra-sight, and working swiftly, is important in every aspect of photography. The photojournalist, or reportage photographer, who records things as they are, has to have this coordination. Even the photographer of formal portraits needs it, to capture that moment when the sitter is sending a vibration straight through the lens, past the film, right to the photographer.

And you also need this special coordination for our kind of photography, which is the converting of things from what they are to what you want them to be. You learn to work inside the limitations, and at the same time, stretch them. All this goes on while you are both looking around you and inside yourself to bring out that inner world for you to see and to show to others.

EXTERIOR CHRISTMAS DECORATIONS

In the business and shopping districts, you can find great decorations at Christmas time. I was particularly impressed by a very simple decoration of two Christmas trees, side by side, reaching up to the fourth floor of an office building. They were simply two flagpoles with a series of poles coming out of the sides that gradually got smaller the closer they were to the top. Small white light bulbs, spaced eight inches apart, were placed on the center pole and on all the branches. It was simple and beautiful, and I shot a roll of it with a wide bracketing of aperture and time settings, in and out of focus, and with camera movement. One frame with slight movement was used for a cover of a science-fiction book about projectiles. The clever thing the art director did with that shot was to use it horizontally. What had been a Christmas decoration in a vertical position became two projectiles moving through space.

GENERAL SCENERY

Combining a location and a person in a multiple exposure, or a sandwich (Chapter 9), gives you the power to juggle and to alter their

relative sizes. You can put a city on one side of a person's face, or put a huge eye in the sky.

The augmenting of the human being vis-à-vis his world is natural. I believe it is more real than the so-called reality of the snapshot of Mom and Dad dwarfed to insect size as they stand in the vastness of the Grand Canyon. Although that snapshot supposedly is what is, we and the people we know loom far larger in our minds than the great largeness of the world and the cosmos. Ask a flea, and he will tell you that he is the biggest being in his universe.

Michelangelo understood this when he painted the Sistine Chapel. He painted heaven, made the people in it so big, and put so many of them up there, so that all one sees in his heaven are the people. Except for the fact that a lot of the people are partly naked, it's almost like the subway at rush hour. Not only knowing how we feel and think, but being human themselves, the early Renaissance painters made the people in their portraits big, and put the scenery far back, so that a tree would be smaller than a person's ear. In art, all people demonstrate an awareness of the vastness of the universe, but the human dimension dominates, and we are compelled to reduce the concept and measure of the totality of the world to our own dimension. The vastness can only be implied.

I photographed a girl outdoors, in closeup, with light only on one side of her face, against a dark background in a sheltered area. This shot is usually hard to achieve in outdoor photography because the light source is dispersed, so that you usually get flat lighting, backlighting, or strong top lighting with pockets of shadows around the features. Take II was the city skyline with a brilliant orange setting sun. Although I had not made a sketch or a diagram of Take I, I composed the shot so that the sun came out on the underexposed side of the girl's face (Fig. 5-4). Otherwise, the sun and the bright side of her face would have cancelled each other out. This color slide was used to advertise sleeping pills.

The chance discovery of a unique outdoor location was used to make a black-and-white portrait. I was photographing houses in the Beacon Hill section of Boston, when I came across a mirrored entrance to an antique shop. I took a picture of a friend who was with me. She sat in a chair in front of the mirror, and I deliberately looked up at my own reflection and included myself in the photograph (Fig. 5-5). This is my favorite picture of myself. Most photographers, I think, are so used to being behind the camera that they get uneasy when they find themselves in front of it.

I used an old three-story Gothic-type house in the country, silhouetted against a strong early-evening blue sky. The eerie atmosphere of the house was accentuated by a single light in an upper-story window. That was take I. For take II, I photographed a girl in the studio with a filmy highlighted drape that fell from her head to the floor. She appeared to be running from the house (Fig. 5-6). This transparency and others like it are mentioned again in Chapter 10 in the section on ghosts.

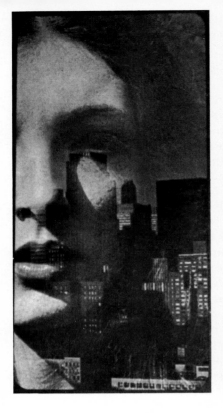

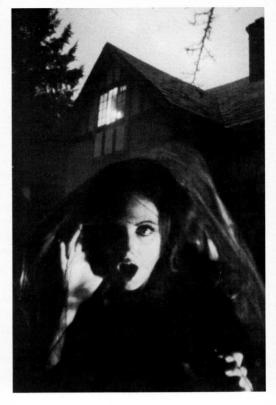

Fig. 5-4. A double exposure of a girl's face and the city skyline.

Fig. 5-6. The "ghost" coming out of the house.

Often, when I'm shooting outdoors and just doing general scenery, I will put my finger in a corner of the lens, or off to one side, the way you use a dodger when printing black-and-white photographs in the dark-room. I do this if I want to insure having a dark area on the film onto which I can add another image in a take II. If it is bright outside, it is advisable to wear a dull black glove when you do this, to prevent the light that can bounce off your skin from registering on the film. Be sure to press the depth-of-field previewer button before you shoot. The size of the "dodged" area can vary according to the size of the aperture.

Again, these few examples are only a tiny portion of the possible ways to shoot general scenery. Needless to say, there is no end to what you can do. And even in this book, as we go on, there will be additional examples again and again.

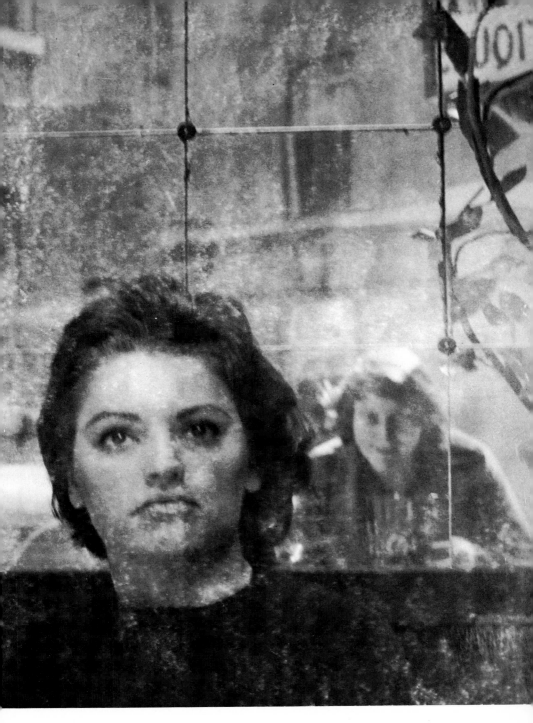

Fig. 5-5. A portrait of my friend—and a self-portrait.

PROPS

Now we come to the things that you find and bring back to the studio—things that you would not ordinarily think of as being useful. But perhaps you will look at them and see something in their shapes or in the materials they are composed of, and begin to feel that you can clothe them with a new reality in one of your special put-together pictures.

The 5 & 10 was one of my favorite hunting grounds for things that sparked my imagination. I had a special 5 & 10 that I would go to, and I would just wander around picking things up, holding them to the light, turning them around. After a while, the salesgirls realized I was neither insane nor a kleptomaniac, and one of them came over to me and said, "We got some new things in I think you'd be interested in." She was right; it was a gratifying moment.

In the sewing department, I found sequins and beads. I bought all kinds of plastic sheeting—clear, frosted, and tinted—by the yard. The gift-wrapping department had gold, silver, and colored foil papers and sometimes colored cellophane. For rolls of colored cellophane, you may have to go to specialized gift and party-supply stores.

I bought Christmas-tree lights, sprinkles, embossed foil papers, shiny and varicolored Christmas balls. Small balls no larger than a fifty-cent piece were my favorites, and I used them for many abstracts. At Halloween time, you will find masks and skeletons available. I traced skeletons and skulls with a grease pencil on clear plastic sheets, which I hung like a curtain across the studio. Behind the plastic sheets I posed children dressed in white sheets and masks (Fig. 5-7).

I made forests and gardens from leaves and flowers bought in the artificial-flower department. Greenery arranged closely together, and sometimes put up against mirrors and photographed together with their reflections, made great jungles on several take II's.

Fig. 5-7. Halloween scene.

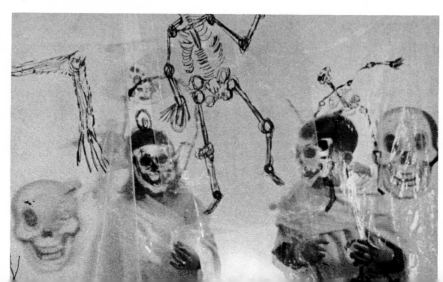

MASKS

There are stores, usually in amusement centers, that cater to the bizarre, the grotesque within us. They sell "horror" masks, which are made out of a skin-like latex material. They also have realistic masks, made out of a stiffer plastic. Some are flesh-colored, and some are pure white; the latter are particularly strange. I have a theory that there's a whole area of man's psyche that is attracted to the concept of masks. The attraction seems to be a crystallization of a particular emotional state, the way a photograph can be one significant extruded facet of a very convoluted, complicated human being.

I decided to experiment with masks and I bought several. This series of black-and-white photographs (Figs. 5-8A to D) illustrates a setup for making a slide with one of the "horror" masks. I mounted the mask in the center of a 16" × 20" black illustration board where I had cut out a hole. I glued and stapled the edges of the mask around the circumference of the hole. I placed this board in front of a light. I put a green scrim over the light behind the mask. I had already cut the mask eye-holes, to make them bigger. The green scrim showed through clearly in these holes, intensifying the frightening look of the whole thing. Take II was the crumpled foil paper shot out of focus.

Fig. 5-8A. The parts of the setup: left, the black board with the hole in the center, the light shining through it; center, the mask; right, the crumpled cellophane that will be used for take II.

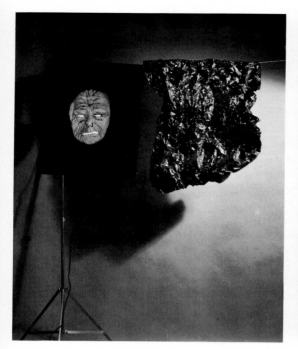

Fig. 5-8B. The mask mounted on the board.

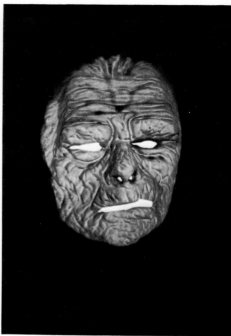

Fig. 5-8C. Take I—a close-up shot of the mask.

Fig. 5-8D. Take II—the illuminated cellophane out of focus. The horror mask will appear to be floating in flames.

I repeated the same setup with a similar horror mask, omitting take II on the crumpled foil paper. Instead, take II and take III were repeat takes of the mask, with only two changes: I used a different colored scrim on the light—take II was red, and take III was yellow; I put the mask in a different position in the frame, and for a few frames allowed takes II and III to overlap with take I. I also moved in and out to change the sizes of the masks, and I did some takes by shooting not at a right angle, but from an oblique angle. Of course, I could have bought three masks, and used three lights with three different colors on them and done it all in one take, but I'm sure it would not have had the mystery and effective-

Fig. 5-9. The frame drawing on the plastic sheet and the kneeling girl.

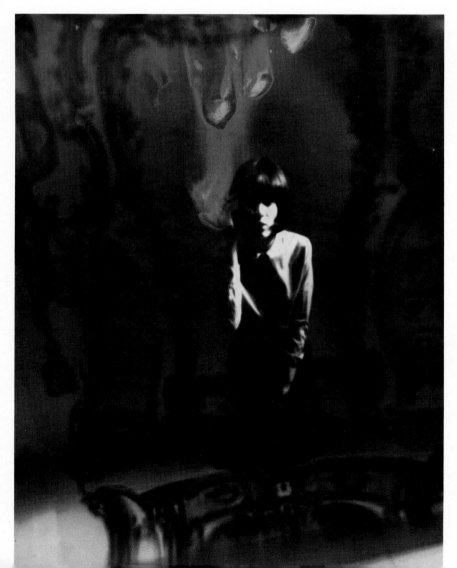

ness of doing it in three takes. By doing a triple-exposure you have more flexibility and you also have the excitement of not knowing exactly what your results might be.

Another thing I did with the horror mask was to shoot it in a single take, filling up more of the frame area with it, and using camera movement. Take II's on these single large shots were always simple abstracts on crumpled foil paper, for color. A favorite shot was made with a slight sideways swipe that gave the mask a happy smiling look. I bought two of the pure-white realistic masks and in Chapter 10 you will find a thorough description of the transparencies I made with them.

If you don't mind going out of your way, go to window-display houses; they have many things that might propel you into various new experiments. I found a large piece of clear plastic sheeting, and on it was a very large black line drawing of an ornate picture frame. I hung this loosely in front of a kneeling girl. The plastic created some distortion (very slight), but the folds in the plastic picked up unaccounted-for highlights. This photograph, showing the girl looking intensely ahead makes it seem as if the frame is holding a mirror; and it gives us, the viewers, the feeling of looking in on something very personal, the impression that we are seeing something we're not supposed to see (Fig. 5-9).

I know that when you go outdoors you will find props similar to mine, and also many, many others. Although we are all alike, and you may start out doing the very same things I have done (even to following some of my explanations step-by-step), ultimately what you achieve will be different. After all, we all exist in our own individual time and place slot. I can assure you that you will have the thrill of creating some very original and beautiful slides.

6

Silhouettes

A silhouette is a photograph, either black-and-white or color, with light on the background only. The subject has no light on it at all and is completely underexposed, or black. Since no light falls inside the shape, all the detail is lost. Whether you shoot an object, or a person's head, or head and shoulders, or full figure, the shape is all that you have to identify the subject. A silhouette has a flat, two-dimensional feeling, since none of the details that normally sustain the impression of three-dimensionality are visible.

Silhouetting is particularly useful and interesting when you are working with multiple exposures. It is the reverse of all the work explained so far, where the unexposed film was the area around the subject, and it was in those unexposed or underexposed spaces where you planned to place your subsequent takes. In silhouetting, it is the subject itself that is unexposed (or sometimes underexposed), and so, conversely, you plan your subsequent takes to fall inside that shape. In the true silhouette, the background has been overexposed, and nothing will record on it; but this can be varied. There are some cases soon to be described, where the background does partially show and does record some of take II.

When you take light readings, make sure the silhouetted area has no reading. You must always be sure that you expose only for the background, so that the subject is underexposed. If you do not wish the background to be completely washed out (overexposed), and hope to pick up something of take II in it, here are some precautions to take:

1. The head, figure, or object can have edge lighting to give it an outline and thus separate it from the background, which is not totally overexposed. In the chapter on sandwiching there will be an example of an edge-lighted silhouette.

2. The other way of creating a silhouette with some underexposed area in the background is to have only part of the background totally overexposed, such as a hot spot behind the figure. In this case, you must make sure that the hot spot is large enough so that enough of the silhouetted shape is recognizable (Fig. 6-1).

A silhouette of a head in profile, or a front view, or a three-quarter view of a head and shoulders are easily identifiable (Fig. 6-2). However, should the model be wearing a coat with a hood, or if she has long thick hair, you can readily envision that it would be difficult to identify her in a front-view silhouette. Or, if the model were to put her arms up over the top of her head (a gesture that children often make) you can again envision that, in a silhouette, one would never know who or what she was. I should also like to point out that if you are using two heads or two figures, carefully study the parts that overlap and be sure that the resulting composite shape is recognizable (Fig. 6-3A). If you are not careful, you might end up with two heads on one body, or one head on a broad body with three arms (Fig. 6-3B). This could be interesting to explore, like the shadow figures that people make with their hands to entertain children. It would be fun to see what new shapes you might evolve, or what strange new creatures you might invent. However, I'm sure you wouldn't be too happy if you wanted a silhouette of a boy and a girl with a pigtail and ended up with the silhouette of an elephant.

Fig. 6-1. Silhouette with a hot spot.

Fig. 6-2. A profile silhouette.

Fig. 6-3B. Another kind of silhouette with two people—funny, perhaps, but generally not as useful as the silhouette in Fig. 6-3A.

Fig. 6-3A. A recognizable silhouette of two people.

Making silhouettes indoors is easier than making them outdoors, since indoors you are in control of the lighting. If you decide you do not want a totally washed-out background, you can have a color for the background, or a design. In Chapter 8, which deals with back projection, you will discover that using your slide projector for back projection is a foolproof way of making silhouettes with designed and colored backgrounds. In these instances, remember take II will be partially picked up by the background.

When you choose the color film to use with silhouettes, that is, indoor or outdoor color-balanced film, I presume that when you shoot your silhouette you will know what your take II will be. If you expect to do take II out of doors in daylight, use outdoor film, even though you are shooting the silhouette indoors. The color balance of the film is of minor importance in take I, the silhouette, so the choice of film should be based on what take II will be.

The bracketing of exposures does not have to be broad. Once you establish that the light reading, and thus the lighting, on the silhouetted area is sufficiently under the reading on the background, a bracketing of one stop over and one stop under the reading is all that is necessary. This gives you a five-stop spread: one stop under the reading, one stop on, one stop over, and the two half-stops in between. The important records to keep in shooting silhouettes are careful sketches and diagrams of the compositions, to guide you so that you place take II precisely in the area of the silhouette, since it is only there that take II will register (except in a not totally washed-out background, where it will register partially).

Let us assume that you are ready to start shooting silhouettes. You might try shooting a person in a close-up profile, then try medium and long shots. Be sure to make diagrams of everything. For take II's there are several things to do. Start off with abstracts. Even if they spill over the periphery of the silhouette, it doesn't matter too much. General scenery is also very good to combine with silhouettes. Just be careful when you expose take II's with scenery: It is very easy to overexpose and completely lose the shape of the silhouette.

When shooting take II's, consult your take I diagrams and make sure that the main areas of take II fall on the silhouetted areas. There is no end to what you can put inside a silhouette, from a single flower to a whole garden. You could do crowds of people, or one other person, fully lighted. You could do traffic, or a view of the city from the top of a skyscraper. If you wish to shoot at night, do theatre marquees, the streams of automobile lights on a highway, or scenes in a theater, ballet, or opera. I have even used pictures shot off a TV or a movie screen. I have also put a portrait of a person inside his own silhouetted profile (Fig. 6-4).

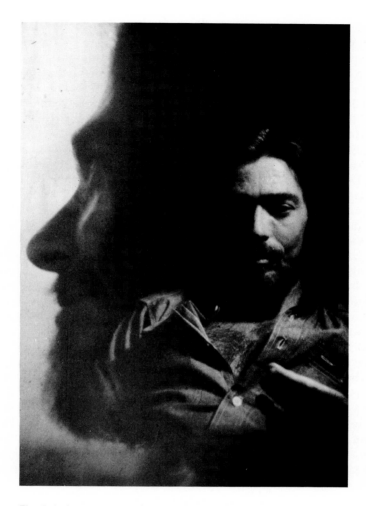

Fig. 6-4. A man inside his own slightly silhouetted profile.

In Barbados, on the silhouetted profile of a Barbadian, take II was an overall scenic of the beach, palm trees, ocean and sky. I did a night city scene of lighted windows and traffic, on the silhouetted figure of a young man. You might try to do a sports event, although I never have. For instance, you can make a silhouette of a football, tennis, or baseball player, and then use the overall view of the actual game as a take II. You might do the silhouette of a child, and then a symbolic shot out of the child's life. Can you see how all these combinations of elements can explode into a multiplicity of effects?

Here are some explanations of silhouettes I have done:

1. I photographed a teen-age boy holding a guitar (a good shape for a silhouette) against a not totally washed-out background. I went outside looking for a likely take II, and found a neon sign that had a series of red lines, which I used. These red lines suggested the lines of the music staff, and I felt they were related to the guitar. The red lines covered the whole frame; they were powerful in the silhouette area, and faded where they crossed the somewhat washed-out background.

2. The slide explained in No. 1 was only half of a roll of film. The other half of the roll had the boy's silhouetted profile, with his head tilted back. I decided to find another take II for that. A few days after I photographed the profile, I had to go to the studio of Pat Sloane, the artist, to photograph her paintings. I took this roll with me. I had taken it out of the camera, taking care to be sure that the leader remained outside the cassette, as explained in Chapter 1. I knew which was the last frame of the boy and the guitar, and where the silhouetted profile started, awaiting a take II. When I finished the job of photographing the artist's work, I reinserted my exposed roll in the camera, lining up the lines drawn on the beginning of the film, as described in Chapter 1. With the lens covered, I moved the film forward to frame Nò. 11, where the silhouetted profile started.

I was going to use a detail from one of Ms. Sloane's paintings for take II. I decided that a heavily outlined cartoon-like profile in vibrant colors would be the take II. Using a diagram to help me, I carefully placed one of the profiles in her painting inside the silhouetted profile. The painted profile, like the photographed one, was also tilted up. It worked extremely well (Fig. 6-5). This slide, plus the one of the guitar, the boy, and the red lines (along with three others to be explained in upcoming chapters), were used to illustrate an article on "Fantasy Photography" in a magazine. That's pretty good going—two published pictures on one roll of film.

Fig. 6-5. A painting inside the silhouetted profile.

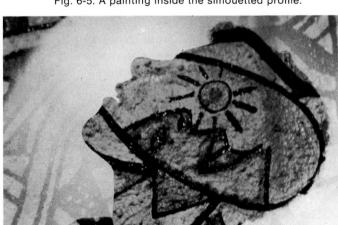

3. I photographed the silhouetted profile of a girl singing. I wandered about the streets looking for a likely take II. I was seeking something that would visually emphasize the quality of singing. What I found was a red, white, and blue neon sign in the window of a shoe-repair shop. The sign was at eye-level, so I could get as close to it as I wished. Many good things are the wrong distance or the wrong height, and it's frustrating to have to let them go.

I decided to shoot at a slow speed, but this necessitated closing the lens down to $f/16$, which is the smallest aperture on my lens. According to my light reading, I would have had to shoot at 1/8 sec., and I wanted to shoot at least at one second or more. In desperation, I put two spread fingers over the lens, as though to squeeze it. Although I already mentioned this "device," this was actually the first time I used it. I had concluded, not so logically, but correctly, that it would cut down the aperture. I find it interesting that intense need, rather than clever thinking, often solves problems. Besides cutting down the aperture, the "device" also changes the form of what you're shooting, over and above the changes made by the moving of the camera. Optically it must have something to do with the shape of the fingers, as the light comes around them. I have also taken a pipe cleaner made of foil, bent it around in a spiral, and it, too, when held against the lens, does something funny but good to the way the image gets recorded on the film.

Well anyway, what came out for my take II was not a red, white, and blue shoe-repair shop neon sign at all, but wavy, delicate, flowy lines that give an impression of sound waves, as though the sound of her singing had been caught and recorded visually.

With this same "singing" profile, I did a take II on a DON'T WALK traffic sign. I liked the slide, and decided to do another one using the same sign. I did a similar profile with another girl that wasn't totally silhouetted, so some details of her features showed. When I reshot the DON'T WALK for a take II on the new profile, I did several frames with what I call a syncopated movement, where I hold still for part of the exposure and then make a whiplash sweeping movement for the balance of the exposure. The result was lettering that was legible, but which had streaks behind it like the music lines of the staff, again, I feel, giving the transparency a feeling of sound (Fig. 6-6). This picture was used as a record-album cover, coincidentally entitled, "DON'T WALK."

4. There have been several times when I photographed silhouettes on "prepared" rolls because I was confronted with an interesting shape, and then put the film away with notes and diagrams until a likely take II came along. Here are two examples:

A friend came to the studio wearing a conventional dark brimmed hat, and a heavy dark winter overcoat. He made a great shape. I asked him to make threatening gestures and photographed him silhouetted

Fig. 6-6. A traffic sign on a silhouetted profile.

against a white background. It was several weeks later that the right-looking model came to the studio, wide-eyed and defenseless looking, and I felt she would be a good take II. Carefully following the diagrams, I placed the model so that she would be completely surrounded by the silhouette, and I directed her to look fearful for some frames, and innocent and unaware for others.

Another shape that presented itself to me as a good silhouette was a young man with a very muscular build. With him I did not do a total silhouette; I picked up a little detail inside the shape to show some indication of his muscle development. I only did one simple, straightforward pose, hands on hips. I used a broader range of bracketing than I normally do for silhouetting, so that I would have a range from total blackness in the figure to what I call a semi-silhouette.

I put this "prepared" roll away (in the refrigerator) with notes and a diagram until several months later, when I was shooting a girl in the nude. I used her for a take II on this roll, framed within the area of the silhouette. One of the transparencies of the semi-silhouette of this set was used as a paperback book cover.

Another shape that lends itself to an effective silhouette is a hand; I have used it several times. Take II's have been abstracts, a face, a whole person, scenery, and a flower.

5. Now we come to an example of a silhouette with a hot spot behind most of the figure. The background is partially white and washed out,

surrounded by an area as dark as the silhouette. (See Fig. 6-1). I had a very strong circle of light behind the body and part of the arms and legs of a male dancer. He was in a lunging position, head thrown back, and arms spread out. His hands and feet were not in the silhouette; they disappeared into the darkness of the background around the hot spot. Since this was an assignment with a specific theme, my take II had to simulate a fiery atmosphere. The shot was to be used for a cover for a science-fiction book about people who lived in an environment of flames. Take II, which would be picked up on the silhouetted area of the film, i.e., the man's body, and on the background around the hot spot, had to be that fiery environment of the planet.

I thought I would try three different types of flames. For the first set of take II's I used a whole box of small birthday candles. I set them very closely together in an earth-filled 10" × 12" black developing tray. Since I knew that these candles wouldn't last long, I set the camera on a tripod, framed the composition, lit one candle and did a light reading on that. I made an exposure chart varying the exposures six ways, in half-stops. Only when I was ready to shoot were the candles lit, and I managed to get through about twenty frames before the candles began to burn out.

For the second set of flames I used the flames in a fireplace, also using a wide exposure bracketing.

For the third set of flames, I crumpled up some bright red foil wrapping paper, and lighted it from the side for highlights. I shot this setup two ways: out of focus, and also on a slow time setting with a little camera movement.

Here we have three solutions to the problem of creating a fiery environment. When I got my results, I saw that my idea of using a silhouette with the hands and feet seemingly pinned to the dark area of the background around the hot spot worked well. The flames appeared on the body and on the background shadow. The birthday candles were over-obviously little spots of fire; the flames from the fireplace, on the other hand, were too mushy, but the last set, with the crumpled gift-wrapping paper, was the best. This is another example of how in photography the real thing may not be as good as the "fake" thing.

6. Now I come to an example of a silhouette done on location, for an assignment to get an atmospheric shot of two lovers around the Washington Square area in Greenwich Village, N.Y.C. This seems to be a simple, straightforward, almost reportage-type shot, but sometimes a simple shot like this is very difficult. The models have to be directed so that you can capture the proper ambience. Pictures of this type frequently come under the category of what I call "implied photography," wherein the message is conveyed through nearly imperceptible shapes and muted colors, rather than through a strong, heavy-handed statement.

I went to the Washington Square area with a young couple in the early evening. It was muggy, and a haze was over everything. This was fortunate, as the pictures would have a muted and soft quality that would lend itself to the overall atmosphere we needed. We just walked around, and I did what I call "grab" shooting, photographing my objects all over—near lighted windows, under the light that filtered down from the lampposts, sitting on park benches, leaning on wrought-iron fences. You will be amazed at how much light there is in the streets at night. Also, don't be afraid to shoot hand-held at slow speeds. If you take a stance with your legs apart and knees slightly bent, and swing your body sideways a bit with your weight a little over one leg, you can hold a camera steady. I was taught that trick by my first photography teacher, Jeremiah Russell, an ex-U.S. Army officer who had been a photographer during World War II. He took the regulation gun stance and put it to work as a camera stance. And it works. That's almost biblical: "And they shall beat their swords into plowshares."

To get back to the shooting with the couple: I was feeling my way about just how much direction to give them, and they were anxious to give me what I needed. It was a subtle thing; the three of us were reaching down and trying to fall into a basic rhythm together, and we did all kinds of shots. The slide that was used for the book cover was one of the couple holding hands and walking across the open space of Washington Square. It's a back view, on a slow time setting, showing slight movement in the legs.

There was one series of shots I did of the couple that turned out superbly, and that was a silhouette. I shot the couple with their arms on each other's shoulders, making sure their heads were separated (as pointed out earlier, two heads together in a silhouette must be handled with care, or the shape can be confusing) and looking up, as though at the stars or the moon; in some shots they were looking at each other. I was down at a low angle so that a street light was hidden behind their heads, shining edge-lighting through their hair and separating their silhouetted heads from the dark sky. I must have shot at least 20 frames of this.

As soon as we were finished, we got into the car; and as we were driving home, it started to rain. Possibly because of the finish on the glass, or the movement of the car, the raindrops on the windshield were not little beady half-spheres, but were splatter drops. Since I always mark my film for use as a "prepared" roll, whether I plan to double-expose or not, I was ready to use it again. These drops became optical devices which picked up and concentrated and reflected all the passing lights and colors. (See Chapter 5.) We drove around in the Times Square area to get extra lights and extra colors. These gemlike and starlike raindrops became my take II on the silhouetted heads, but I shot only on

every other frame. Not being sure of this extra exposure, and wanting to have some single takes of the silhouetted heads, I covered the lens, and pressed the release button, and moved the film forward on the in-between frames.

The results were beautiful, with the splattered shapes adding an emotional quality that was perfect for the silhouettes of the lovers. The heads silhouetted against the sky in take I came out in soft, dark, muted purples and blues, and the edge-lighting around the heads of the couple was a green-blue silvery highlight.

I don't know what it is that brings the right elements together. Some call it luck. But it also has to do with striving, working hard, and really wanting something to happen.

As I have said earlier of previous topics, the subject of silhouettes will come up again, but as they are combined with other techniques, I will talk about them in the chapter where the other techniques are featured.

7

Using Black-and-White Photographs

Having been a photographer for so many years, I have a large file of black-and-white photographs, including many portraits. Sometimes, when faced with a problem in multiple exposures on color film, I would realize that a certain black-and-white portrait would be a perfect solution for that particular problem. And I would try to think of ways of recreating the portrait with color film. Suddenly, the thought came to me: Why should I try to recreate the existing photograph, when I might be able to copy it? And so, I developed a method of copying an existing black-and-white photograph on color film. I use color filters on the lens to restore flesh tones to the picture, and then I might double expose on a chrome surface or an abstract to fill the shadow and dark areas with color.

Around the same time that I was experimenting with this technique, I bought a star filter, which is a lens attachment (cost, around $10). A light facing the lens with this attachment on it will have its rays split into crossbeams. With one star filter on the lens, you get four beams radiating from a central point. But you can put one star filter on top of the other, and so get eight beams.

Very often, I develop a new technique when I have some free time and want to start on something just to have fun. Or, I get an image or thought in my head that I feel I must express, and I just start putting things together. You will probably find yourself doing the same thing. In this case, I accidently bought the star filter just about the time I started working out the problem of using black-and-white photographs, and the two things complemented each other. I'll show you how.

I realized that the best portraits to work with (although I used other black-and-white photographs besides portraits) were those with a black background. However, the first portrait I worked with did not have a black background. Taken in the street, it was a photograph of a man with an intense expression. I had experimented with it in the darkroom making many prints using different croppings. I cut the head out of six prints and blackened the cut edges with a felt-tip pen. I pasted these heads on the bottom half of a large sheet of black paper, in two rows of three each. I then hung the sheet from the horizontal bar of the light stand.

Simultaneously, I decided to try out my new star filter. Realizing it worked best with light coming directly into the lens, I punched holes in the pupils of all the eyes of the six portraits. I placed a light behind the black paper and the beams of light came through the holes in the eyes. Of course, I also lighted the front of the montage, since I wanted the face to be seen in the picture. I knew that I'd have to be careful to keep the front light from overpowering the beams of light coming through the eyes, and so I looked through the viewfinder to see if I could see the beams. I could. Crossbeams of light were coming through every eye, though some eyes showed more beams than others. In order to measure the difference in the light reading between the beams and the front lighting, I turned off the front light and took a reading on the beams. Then I turned off the back light, which created the beams, and took a reading on the front light. The beams were two stops brighter. If there hadn't been that much of a spread, I would have had to make an adjustment by moving the front light closer or further away. There is no such latitude with the back light, which must be as close as possible to the holes in the eyes. I then set up a frame-number and exposure chart, based only on the front-light reading. I decided to ignore the light reading on the beams, once the two-stop spread was established. I also felt that wide exposure bracketing would be necessary, since this was the first time I was working with the star filter and black-and-white prints. I also used a flesh-colored filter on the lens, though I had no idea how well it would work with the star filter. But it worked well.

With only the front light on, the reading was $f/4$ at 1/30 sec. The reading on the beams was $f/8$ at 1/30 sec. I shot a few frames slightly out of focus. What was interesting in the exposures was that the beams, being so thin at $f/8$, were swallowed up by the surrounding darkness, and all that showed were white holes in the eyes just starting to become crossbeams. For take II, I used some pieces of red, blue, green, and yellow paper, and shot out of focus, with some camera movement. I avoided any highlights that might have interfered with the beams, since the beams were the "main theme" of this project. Take II warmed up the black areas and the shadow areas of take I. There were many good slides on this roll, but I preferred the darker ones.

Demonstration Exposure Chart for
Portraits-and-Crossbeams Shot

Frame #	Exposures		Results
1	f/1.4	1/30	everything is too light
2	f/1.4–2	"	
3	f/2	"	fair
4	f/2–2.8	"	
5	f/2.8	"	excellent
6	f/2.8–4	"	
7	f/4	"	beams good–faces slightly dark
8	f/4–5.6	"	
9	f/5.6	"	beams good–faces dark
10	f/5.6–8	"	
11	f/8	"	no beams—square spots for eyes,
12	f/8–11	"	almost no faces

The light-meter reading was f/4 at 1/30 sec. for the faces and f/8 at 1/30 sec. for the back-lighted eyes, but to get a full crossbeam effect in the picture the light-meter reading for the eyes had to be ignored.

No one realized that the faces were taken from a black-and-white photograph. The beams of light came through brightly, and the overall impression was intriguing and mysterious; the picture aroused the viewers' curiosity. Everyone, including very experienced photographers, asked me how it was made. No one could figure it out. The transparency was used for a cover for a book about spirits; and because the main part of the composition occupied the bottom half of the slide, there was plenty of room on the top for the title and copy (Fig. 7-1).

Several years earlier I had had a magazine assignment to photograph in Arizona. During that time I made a portrait, which I still had, of an American Indian, on a black background. I also still had a color print I had made of a desert scene, with cactus in the foreground and a brilliant sunset sky. I took these two pictures, the black-and-white and the color print, and put them together with a double exposure for the cover of a book about ghost stories of the Old West.

Take I was the desert scene: I made a copy of the existing color print, using a wide exposure bracketing. I don't know if it is necessary, but I would like to explain again why a wider exposure bracketing is needed for multiple exposures than is needed for single-take pictures. In this

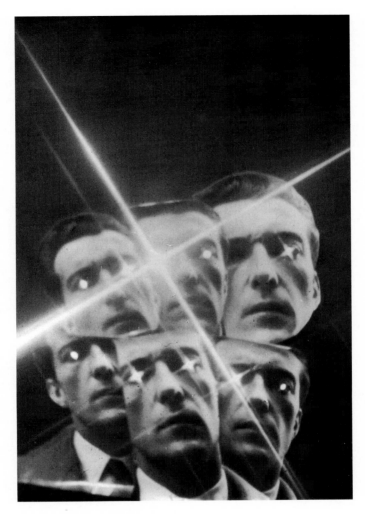

Fig. 7-1. The mysterious montage.

particular case we are working with an area, the sky, that is not black but brilliant orange; the second image is going to be placed in this area. We know we are going to lose some of this brilliant orange color, but we must maintain an indication of it. With a wide bracketing, we stretch the range wherein the highlights of the second image can be stronger than the tonalities of the first print, and the colors of the first take can fill up the shadow areas of the second take. A wide bracketing is like gambling with all the odds covered.

Take II was the portrait of the Indian. I used a black mask in front of the lens. This was just a piece of black paper with a hole in the center; I moved it back and forth in front of the lens so that only the head in the portrait would come through and register on the film. I placed the head very carefully in the frame, in the area of the sky of the first take. This head was large, and it filled up a big area of the sky (Fig. 7-2). There was also a flesh-colored piece of cellophane on the lens to give the black-and-white picture a flesh tone. With this take, a wide bracketing exposure was also used. I had to contend with the fact that the black mask reduced the light reading.

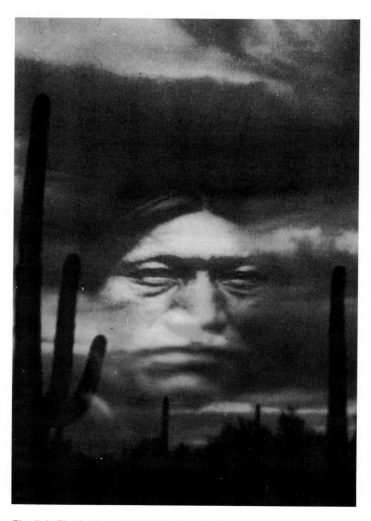

Fig. 7-2. The Indian spirit in the desert sky.

Besides using the black-and-white photographs that I already had, I also took some black-and-white photographs specifically for the purpose of making color slides from them. Essentially, I did this because I liked the particular effect I got with color slides made from black-and-white, and also because sometimes I wanted to work with prints, and black-and-white prints are easy to work with. For example, I got an assignment to do a color slide illustrating witchcraft. Here are the reasons I photographed the model in black-and-white before copying onto color film.

1. I wanted to use the star filter to get light beams coming out of the model's eyes, and obviously you can't do that with a live model or a color transparency.

2. I had an existing black-and-white photograph of a cat's head staring straight ahead that I wanted to use for this illustration, and I wanted light beams in the cat's eyes too.

3. There would be a need to change the relative head sizes of the cat and the model, and this could be done easily in the darkroom if I was working with prints.

4. There was a layout to follow with the two heads in specific positions. This would be impossible "live," but possible with two black-and-white prints.

I mounted the two prints on the black paper in their designated positions, hung black gauze in front of the montage, and cut holes in the gauze in front of the heads. The gauze was forward enough to be out of focus, and it helped disguise the fact that the heads were just two black-and-white prints mounted on a black board. (The gauze would also enable me to leave some of the frames on the roll without a take II, because it would cut out the background and add its own unusual effect to the pictures.) While shooting the setup, I referred to the "six-head" exposure chart. (See p. 92.) I adjusted the lights both front and back, until the light readings for the witch and the cat matched the "six-head" light readings. I then followed the chart.

For take II, which was exposed on every other frame, I decided that I wanted streaky circular lines. I attached small multi-colored Christmas-tree bulbs all over the black paper, except where the heads were, with black masking tape, and then I covered the heads with black paper. (These lights were on dark green wires, which become totally underexposed when the bulbs are lighted.) Take II was shot at $f/16$ at 1 second and 1/2 second; I shook the camera and also made circles with it during the exposures. The results were satisfactory (Plate 11).

A photograph that you take casually can set off a train of ideas, and you find that you end up with something apparently unrelated to the original photograph. Here is an instance of one such thing that happened

to me. A friend and I had worked on a project, and we were studying the slides on the slide sorter. When we were done, we put the slides away and started discussing what we had accomplished. However, we forgot to turn off the light on the slide sorter. That was wonderful lighting on my friend's face, so I picked up my camera and quickly took some pictures of him in black-and-white while he was talking.

I decided to make an enlargement of one picture of him with his mouth open and his eyes cast up. In that shot he looks quite happy, positive, and animated. With all the manipulations I performed, the transposition of the black-and-white portrait to color changed the whole emotional content of the portrait. In the finished color transparency my friend is in a state of fear, terror, and agony. I put this transparency in my slide show. This particular slide is in the voyage-to-hell sequence, and people gasp when this slide comes on. It is an unforgettable image.

To achieve this transformation, I made an 11" × 14" black-and-white print (Fig. 7-3A), trimmed off the borders, and mounted it in the center of a large piece of black paper. I cut out the area inside the lips, and put holes in the eyes (Fig. 7-3B). I stuffed the mouth with crumpled red cellophane. I used the same lighting I used for the previously described project on the witch and the cat. I put a piece of pink cellophane in front of the lens to restore flesh tones in the highlights of the face. The light behind the eyes for the star filter spilled over and turned the red cellophane into something that looked like flames. There appeared to be a fire inside my friend, and he seemed to be screaming in agony. Take II was some simple out-of-focus spots of color to fill up the black background (Plate 9).

For a transparency to illustrate the many sides of an adolescent boy, I worked with only one black-and-white print. For each of three takes the same portrait was placed in a different section of the frame. Take I was photographed from the front with a red lens filter. Take II was photographed at an angle with a green lens filter, and the face was stretched. Take III was photographed with a yellow lens filter, and reflected in polystyrene, getting a wavy distortion. I could have used a model and taken the same shooting, but I felt that using the same, unchanging still photograph three different ways would give a special twist to the transparency.

I've done many other treatments of black-and-white portraits. I've copied a portrait with a flesh-colored lens filter, made it large and out-of-focus for take I, and then I've done the same portrait small and sharp and in the background for take II. The impression is that you, the viewer, are seeing two different aspects of the same person simultaneously. I've done the same thing with two different faces, using different colored lens filters, or different colored scrims on the lights, for each take.

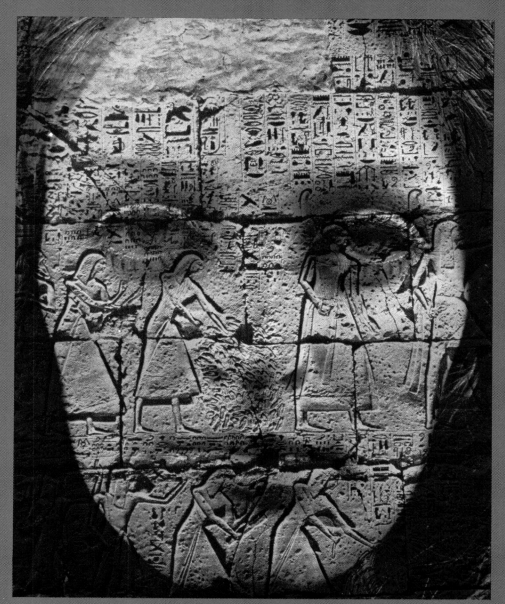

Plate 1: See page 116.

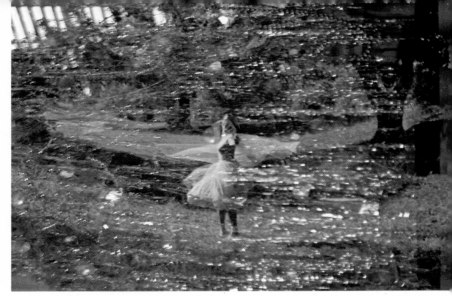

Plate 3: See page 156.

Plate 2: See page 106.

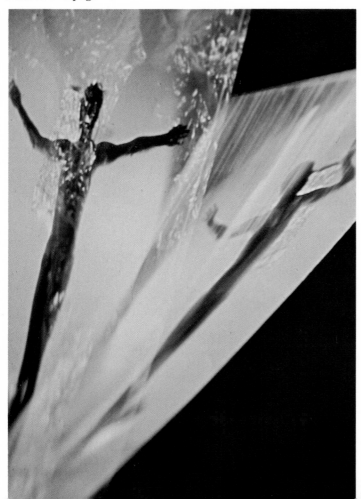

Plate 5: See page 144.

Plate 4. See page 27.

Plate 6: See page 101.

Plate 7: See page 41.

Plate 8: See page 66.

Plate 9: See page 96.

Plate 10: See page 142. **Plate 11:** See page 95.

Plate 12: See page 104.

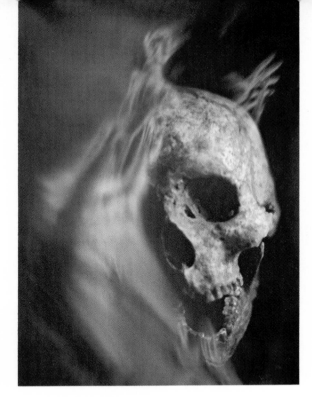

Plate 13: See page 98.

Plate 14: See page 135.

Plate 15: See page 152.

Plate 16: See page 153.

Fig. 7-3A. The straightforward black-and-white print.

Fig. 7-3B. The same print with the eyes cut out for the light beams and the mouth cut out for the "flames" of red cellophane.

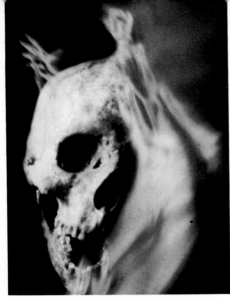

Fig. 7-4. The ghost dancing around the skull.

Here are some examples of subject matter other than portraits that I transposed from black-and-white to color:

I took a black-and-white print of an airplane resting in a field, cut out a hole in the nose of the plane, and placed a light behind it. I then photographed the print with a star filter and an orangish piece of cellophane on my lens. With the star filter, the light coming through the nose of the plane looked like a hot spot from the sun. Then, with the plane in the center of the vertical frame, I put a take II of two people in a lunging position below the plane. They seemed to be running forward from the plane; and the shot became the cover for a spy book set in a desert locale.

I took a 300-year-old medical drawing of a skeleton and its muscle structure, and after I made a reverse black-and-white print, it became a white drawing on a black background. This, reflected in polystyrene, I double exposed around a closeup of a skull. The polystyrene gave the skeleton a wavy undulating appearance, so that it seemed to be dancing around the skull (Fig. 7-4, Plate 13).

There are many more possibilities to develop in this area of transferring black-and-white photographs to color. I've thought about some of them, but I just haven't gotten around to trying them. For instance, I'm sure there is an imaginative way to use old snapshots, historic pictures, memorabilia, etchings, technical drawings, graphic designs, or even newspaper print. You could also get a time-out-of-kilter thing going, overlapping pictures of a person at different stages in his life. The camera can photograph only what is, but we can add certain materials and use the camera to break out of our own time box, fly around in time, and mix time up, the way we do inside our minds and in our fantasies. This thought makes me think of Aristotle's statement, "A work of art should imitate the movements of the mind, and not an ordering of facts."

8

Using a Projector

I love this work because there are always surprises. You never know what can present itself for you to use as a device. You look around at all the familar things, and suddenly, it is as though these things are reborn. They become something else. You use them for something they were not designed for, and they become tools through which you express your thoughts and ideas. That is what happened with my slide projector. I used it to project on "wrong" surfaces, rephotographed the projected image, and this synthesis, in turn, became a new image.

Here are some of the "wrong" surfaces I used:

1. A white plastic copy of a classic head, bought in an art-supply store (around $5).
2. Human bodies.
3. The back of a translucent plastic sheet, which in turn became the background for a silhouetted figure.
4. Ferrotype tins, polished mirror-like 10″ × 14″ stainless-steel plates.

WHITE PLASTIC HEAD

A transparency of the white plastic head, with projections on it, was used for a lead editorial page in a magazine to symbolize the place of advanced mathematics and computers in the financial world. The head was put on a table covered by a black cloth, in front of a black background. The image projected on the head would bend and slip around the contours of the head. If you think of it in reverse, the bends of the projected image would define the shape of the head, or any other three-dimensional form you might be using.

The art director and I decided to copy math equations and graphs and project them on the head. With a close-up attachment on the lens, and

high-contrast black-and-white film, I photographed the equations and graphs in an advanced-mathematics book, varying the exposures to insure getting negatives with good density in the white areas and clarity in the numbers and lines. Camera distance was varied to get different amounts of material on each slide. These black-and-white negatives were then cut up into single frames and, together with colored pieces of gelatin, put into transparency mounts. The colors used were red, green, blue, yellow, orange, and purple. I got open mounts from the color-processing lab. Instructions for inserting and sealing are in Chapter 9. You can also buy empty mounts in a photo-supply store.

I made at least twenty slides, so that I would have a good selection to pick from once I started projecting. I hope you realize that each mount held two pieces of transparent material, a black-and-white negative and a colored gelatin. In effect these were sandwiches, which will be dealt with in Chapter 9.

Now comes the tricky part. The white plastic head was set up on a table, sufficiently far from the background so that any spill from the projected slide would fall into empty space, not on the background. For this project I used three projectors. With three projectors you can cover the whole face—one projector for the front of the face and one for each side. The three slides were projected simultaneously; each was of a different color and each contained different mathematical formulas. After we started projecting, the art director decided he preferred the formuals to the graphs; but I decided I would shoot some pictures with the graphs.

This project took time and patience. The head had to be moved around, different slides had to be tried, the projectors had to be moved back and forth, tilted, and angled. We had to decide how to overlap some of the projections. You could do this alone, but it's easier if you get someone to help you. There are so many variables, and with each change you have to run back to the camera, study the new effect through the viewfinder, and decide what to try next, until you feel what you have is right.

The only source of light comes from the projected slides, so getting light readings can be difficult. Take your time, be careful with the light readings, and be prepared to have a wide exposure bracketing.

I wanted as much sharpness as possible and plenty of depth of field, so $f/8$ was to be the largest aperture. A tripod had to be used; and since this was a still life, the exposure-bracketing spread would be accomplished mainly by varying the time settings, with some variation of the apertures. You must plot your exposure chart before you start shooting and then follow it as you shoot. My reading was $f/11$ at 1/4 sec. For my first three sets I used variations of the math formulas. For my fourth set I used the graphs; and the way the straight lines of the graphs bent,

curved, and wrapped themselves around the head without losing their identity was quite beautiful (Fig. 8-1, Plate 6).

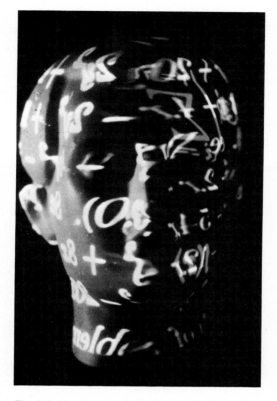

Fig. 8-1. Numbers projected on a plastic head.

The transparency of the head with the varicolored math formulas was used in the financial magazine. The head with the graphs was used as a cover for a science-fiction book. Based on these printed pictures, I got an assignment to do something similar for an interior-design magazine, with room-setting plans projected on the head.

There are so many other things you could do with this basic setup. For projected slides you could use line drawings, etchings, movie signs, posters, advertisements, stock-market quotations, or symbols. Just let your imagination go, and then perhaps make up a whole variety of slides from black-and-white negatives and color gels and have them ready to try out interesting projects. If you use color film to make copy slides from the negatives, you will have projections that will be positive, or identical to the material originally copied by the black-and-white film.

HUMAN BODIES

I used human bodies as projection screens, projecting an abstract slide on two dancers in white tights and leotards. They held their poses for me, and I hand held the camera and shot at a wide-open aperture. The principle was the same in this shooting as in the shooting of the projections on the white plastic head, except this time there wasn't much necessity for precision.

Another similar situation, which I didn't shoot, occurred during a showing of the slide show in a church. At one point the minister moved in front of the screen, and a slide of the man's face with a very poignant expression showed up very clearly on the minister's white cassock, between his upraised arms. The congregation was deeply moved by this.

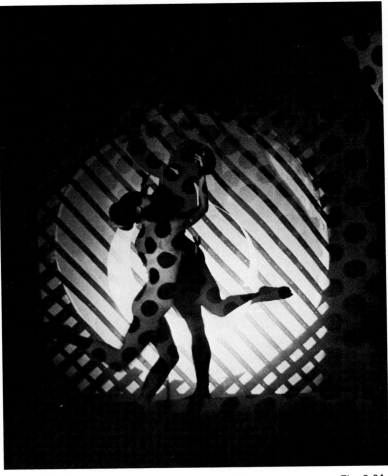

Fig. 8-2A.

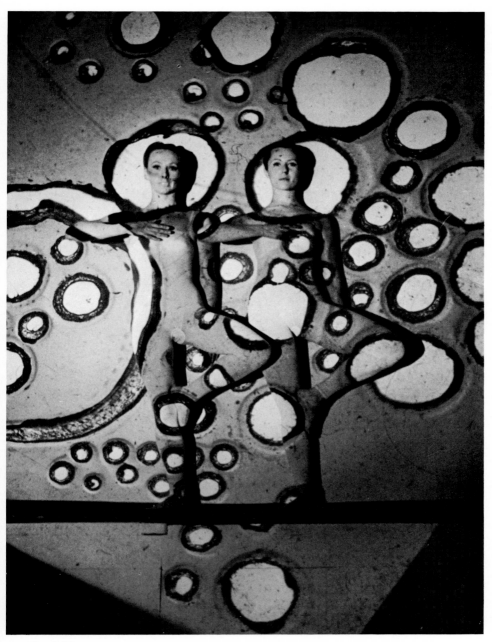

Fig. 8-2B.

Figs. 8-2A and B. Human bodies used as projection screens.

BACK PROJECTION

You can make your own back-projection screen and do some wonderful work with it. Finding frosted colorless plastic sheeting can be difficult, so what I did was to get several sheets of nearly clear plastic and hang them from a line I strung across the studio. They formed a sheet that was 36" wide by 50" long. That is large enough to allow a medium shot of a person standing at least one foot in front of the sheet (Fig. 8-3). Since you'll have the projector on one side of the sheet, and you and model on the other side, you need a long area to work in. (With a 35mm lens on my camera, I worked in a 24'-long area.) What you are doing is creating a silhouette. I have always used a "screen" that hangs flat, but you could get some interesting results if you draped your sheet with folds, like a curtain, or if you pushed something against it so that it would bulge, or pulled it at some point with a fishhook on a nylon line. In this kind of photography anything goes—if it works. The person you get to pose in front of the screen should be relaxed and be able to move well. It would be good to get a dancer or a child. This project is like a game of "Statues" you played as a child. The model will have to make poses, and hold them. It is a good idea to have the model face the screen and react to the image on the screen, as though the model and the image were partners doing a dance. Also, remember, profile views work well (Fig. 8-4).

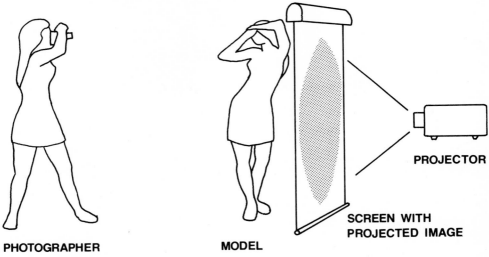

PHOTOGRAPHER　　　　　**MODEL**　　PROJECTOR

SCREEN WITH PROJECTED IMAGE

Fig. 8-3. The back-projection setup.

And what would you project on the screen? Anything—abstracts, a portrait, a crowd, a country scene, a still life, an animal, a city street, and so on. Remember, your sole source of lighting is the light from the projection, so be careful of your exposures (Plate 12).

104

Fig. 8-4. Profiled girl and back projection of face.

I projected a predominantly red abstract slide, and my model, facing the screen, posed with both arms up. The brilliant swirling colors of the projected abstract slide came out on the transparency brilliantly. The model was a complete silhouette, but the pose was so simple that its meaning came directly across. The slide was used for a cover for a book about voodoo.

As I wrote this I got an idea, which I will try out as soon as I've finished this book. As you know, no multiple exposures are used in back-projection work, but I just realize how they can be used. Since the exposure settings are based solely on the light of the projected image, the model is totally underexposed; in fact, the model is a black silhouette. Well, if you made a careful diagram of the model, you could then do a take II inside the silhouetted shape.

FERROTYPE TINS AS PROJECTION SCREENS

I had some transparencies on file that I had made for myself after I had completed an assignment using a male dancer for a model. I had admired his movements so much that I decided to shoot a roll of him just dancing as he wanted to. He was barefoot and wearing practice clothes, black tights and a sleeveless orange top. The lighting on him was subdued, and the background was a white wall. One of the movements he made was to just rise up on his toes, stretch his body upwards, and start lifting his arms slowly like a bird getting ready to fly away. It was a simple movement, but very beautiful, and I photographed the arm-movement sequence in its various stages.

About a year later, when I was going over my slide file, I became entranced with this series of slides and decided to project them. I enjoyed seeing the feeling of flight they conveyed, and admired the fact that this earthbound man, a dancer, could so capture the essence of the movement of another species. I thought that I, by my work as a photographer, would try to release him from his earthboundedness and really let him fly. I would try to bring about through the techniques of photography the completion of the movement he started.

Motivated by this thought, I started tilting the projector. I had a great time projecting all over the studio, up on the ceiling, into corners, sideways, down on the floor, on curved white background paper; stretching the dancer to carry forward his movement beyond what he could do; elongating his body and legs, till his feet seemed to leave the ground. But I still felt something was missing. I thought I'd try projecting on something other than the wall.

I got a ferrotype tin to use for a projection screen; it was not an intellectual decision, but a sudden inspiration, an almost desperate reflex action of reaching for and dimly knowing what I felt was needed. I propped this 10″ × 14″ mirror-like piece of steel on a black-covered table, in front of a black background. I think I leaned it against a book or a vase or something, and tilted it. When I projected the flying image on it, it gave me the shimmering silvery quality I felt was needed. The tin gave the image a translucent quality, an airy feeling that the wall projection didn't have, and I liked that. I angled my camera too, and so the image was manipulated three ways: I used a tilted projector, a tilted surface to receive the projection, and a tilted camera. Part of the projected image spilled off the tin, falling into black space and disappearing.

This was a double exposure, but unlike any other already described. Take I was a photograph of the projection on the ferrotype tin, filling up only half of the frame, the left side. Take II was identical to take I, and I actually placed it next to take I in the other half of the frame, the right side, slightly lower, with a slight overlap in the center of the frame. This slide is in the slide show as a symbol of resurrection (Fig. 8-5, Plate 2).

There is a delicate shadowy area in our work, to be determined by each photographer individually, where reality leaves off and becomes something else, something implied. I hope I am conveying to you the excitement one gets out of this work, finding this, getting that, putting bits and pieces together, and making a new living thing, a new image; and I hope I am conveying all the satisfaction you can have even before you get your results. I guess we all have something of Pygmalion in us.

Fig. 8-5. Take I and take II of the dancer projected on a ferrotype tin.

Sandwiches and Montages

FILE SYSTEM

A good file system for your slides is very important in this work. It should be organized so that you know what you have and where it is. Of course, if you get excited or inspired and want to see something, or if someone calls you and says that he needs a slide that could be used for such and such, and that he will pay "x" number of dollars for it, and you start looking, that beautiful file system can get out of order very quickly. But then all you have to do is to sit down quietly and patiently and put the slides back in order.

When my slides come back from the processors, I go over them carefully, studying them to see if I got what I wanted. Sometimes you discover that you got something better or different than expected. I feel that studying the slides is a very important phase in the work process. After thoroughly reviewing all the slides in the take, I then edit them. If the slides are for a job, I deliver the ones I think are best. Then I divide them up into best, second best, and terrible. I very seldom throw anything away, unless I have too many duplications. Even if you never use a slide, it can be so helpful having it in the file system, where you can easily get at it and see it even long after you've taken it, at a time you may have something totally different in your head. It can start a whole new chain of ideas.

I have a consecutive-number-and-category file system. I give each shooting its proper number, which I mark on a calendar. Along with the number, I write a short description of the shooting. Then I have about ten different groupings—for example, female heads, male heads, scenes, abstracts, mystery, and so on. Some people put down the job or project number and the group designation (generally a letter on each slide). I don't. I keep some slides on showcards, organized according to subject

matter. I keep some slides in trays ready for projection, and I keep the rest in the small boxes they come in from the lab, with the boxes numbered and in their respective group.

This file system is particularly important for finding material and ideas for sandwiches and montages.

SANDWICHES

So far we have worked almost entirely on multiple exposures, where the principle is to get unexposed and underexposed areas in take I, so that there is unused film, or partially used film, for take II; or to put it another way, there must be dark or black space when you organize your take I. In sandwiching, the reverse holds true. We use the term "sandwiching" when two transparencies are put together in one mount. Therefore, clear or light areas are needed in each transparency, so that the two separate images can be seen through each other; they can interrelate and interweave, thus creating a brand-new image. The area of the first transparency that is dark will hold back that part of the second transparency that falls over the dark area, and vice-versa. You should be conscious of both elements; how the light areas of the two transparencies interact, and also, what you lose in the dark areas.

To understand this better, spread out a variety of transparencies on your slide sorter or light box. To start, work with single-take slides, mainly abstracts and heads. This is the time when you will find that your "terrible" transparencies are useful, especially overexposed ones. Don't limit yourself to 35mm slides. Put 2¹/₄" square or even larger transparencies on the light box. With your slides in front of you, just start putting one on top of another at random. Study them, see how they work. Sometimes two will work if you turn one around or upside down, or if you flop it. See how colors change when one slide is laid on top of the other. See what happens when the dark area of one transparency obliterates part of the image of another. Study the way different colors and shapes change as they weave in and out of each other.

When sandwiching with 35mm transparencies, you almost always have to have the slides in alignment. It is possible to shift a little bit, but if you shift too much you might end up with a picture area that is too small. Although I have never done it, you could also turn a slide around sideways, but you must realize that this results in a 24mm-square area (a little less than one square inch) for your picture. The larger transparencies, 2¹/₄" square and up, give you more latitude to work with in sandwiching: You can shift the transparency so that the edges and the frame lines don't have to meet, and if you turn the transparency around sideways, you don't cut down on your picture area. It is because of this that the 2¹/₄" camera was used for three of the seven projects soon to be described.

Figs. 9-1A to C. An illustration of how sandwiched slides will interact.

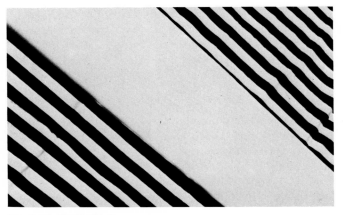

Fig. 9-1A. Slide No. 1.

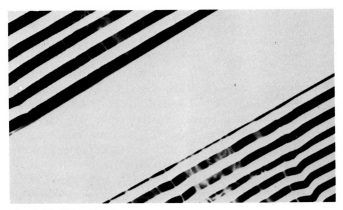

Fig. 9-1B. Slide No. 2.

Fig. 9-1C. A sandwich of slides Nos. 1 and 2.

Sandwiching is also a way of feeding color into color-slide copies of black-and-white photographs, line drawings, lettering, and mounted black-and-white negatives (See Chapter 8.) For sandwiching with 35mm transparencies, you need empty, open, cardboard transparency mounts. When you have 2¼" square transparencies you wish to sandwich, make sure that they are still in their acetate sleeves, and then Scotch-tape them together so that the tape does not cover the picture area of the sandwich.

If you have found 35mm slides you wish to put together, you have to remove the transparencies from their mounts. I suggest that you first practice on a couple of slides you are sure you will have no use for (another reason to keep "terrible" slides). With a single-edge razor blade, make cuts (not too deep) diagonally from the four inside corners of the cardboard mount to the outside corners of the mount. Then slip the blade carefully under the inside edges of the mount, being sure not to pierce or cut the transparency. Dotted lines in the illustration (Fig. 9-2) show where you gently bend up the cardboard mounts away from the transparency. You pry these edges up, and then grasp the bent-up edge with your fingers or with a pair of tweezers. Once you get one side off, it is fairly easy to get the other three sides off, and the transparency will easily come out. Be careful, and avoid getting finger marks on the transparency. Have a clean piece of paper on the table for the transparencies to fall on. Get an empty mount ready and carefully lay the two transparencies on the open mount. Then close the mount and seal it. The kind of mounts I use have a dry adhesive on the inside; this adhesive melts and seals when heat is applied. There are tacking irons sold in camera stores for this purpose, but I use an ordinary household iron. There are mounts which are closed and require pushing the transparencies into position. I don't care for those. If you have made some experimental sandwiches from existing slides, I suggest that you project them and see how they look blown up.

I explained earlier that transparencies larger than 35mm were better for sandwiching than 35mm slides, so whenever a 35mm camera was used in the ensuing projects instead of a larger one, I will give the reasons for it.

Fig. 9-2. To remove the transparency from the mount, cut carefully along the dotted lines as shown in the illustration. Gently lift the sides of the cardboard mount away from the transparency.

I had a photograph that I took a few years earlier of a dancer leaping, with a scarf trailing behind him like a bird's wing (Fig. 9-3A). I had made a "stretched" black-and-white print of it (Fig. 9-3B). By "stretching" I mean that, when projecting the negative of the print in the enlarger, I tilted the easel so that the dancer's body was elongated, and he appeared to be soaring up in mid-air. The scarf behind him turned into a wing-like shape. (This technique is related to the one explained in Chapter 8.) The dancer was in a spotlight, and the background was dark. I made a black-and-white copy negative of the "stretched" black-and-white print, and so the winged dancer became a black silhouette on a clear background. I used a 35mm camera here, instead of the 2¼" camera because I knew I would be using an overall abstract slide, and so no shifting of the two transparencies would be necessary. I then sandwiched this black-and-white negative with a flame-like abstract slide of an out-of-focus

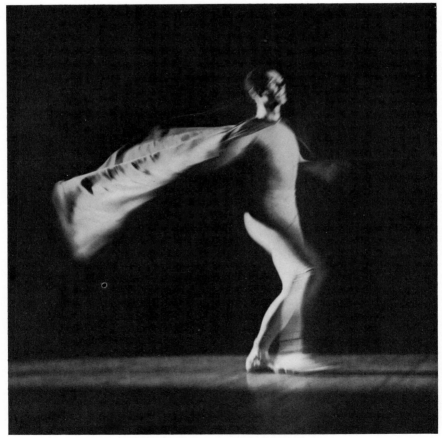

Fig. 9-3A. The original photograph of the dancer wearing a scarf.

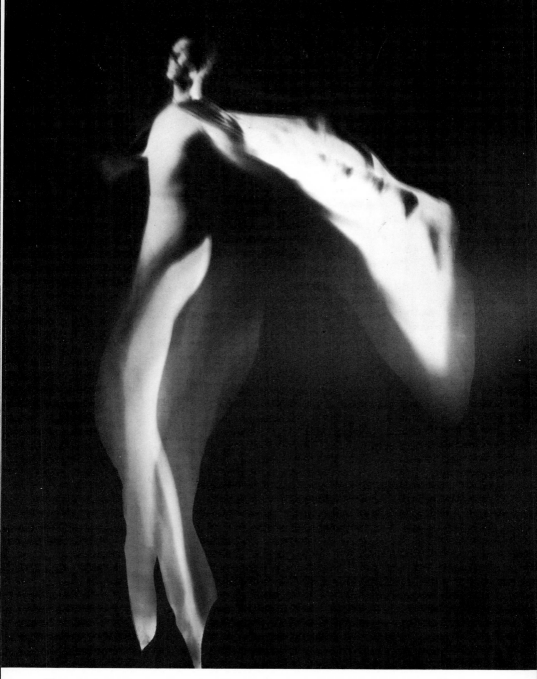

Fig. 9-3B. Tilting the image of the dancer on the enlarger easel produced this "stretched" version of the print. The dancer seems to be soaring and the scarf has become a wing-like shape. A copy negative of this shot was made, and it was sandwiched with an out-of-focus piece of crumpled red foil paper to produce a picture of a black, silhouetted dancer surrounded by flames.

piece of crumpled red foil paper and yellow highlights (from a scrim on the light when I made the slide). Only a sandwich could give me a black silhouetted dancer surrounded by "flames." If I had photographed the black-and-white print in color I would have had, like the print, a white dancer on a dark background. With that I would have had two possibilities: First, a sandwich that would show "flames" inside the shape of the dancer on a black background; second, a double exposure that would have given me a white dancer surrounded by "flames." Another thing could have been done with the black-and-white negative of the black dancer on a clear background: I could have made a reverse negative (called a "film positive") and then made a print of that, getting a black dancer on a white background, which, when copied with color film and double exposed on the "flames," would have resulted in having the "flames" inside the shape of the dancer on a white background. Shall I go on? Let's do one more. Let's take this very last double-exposed slide and sandwich it with another slide, perhaps a slide of pale blue with white cloud-like shapes. The "flames" inside the shape of the dancer could hardly be affected by the blue, and we would have a flame-colored dancer leaping through the sky.

Well, enough of this digression. I didn't carry out any of these possibilities, but it's fun to see how much you can do with one small thing, once your catalog of techniques starts expanding. I just carried out the first possibility, the sandwich resulting in a black-silhouetted dancer surrounded by flames. It was used for a cover of a book about specters. And now, let's get on with the next sandwich project.

A sandwich was used for an assignment to illustrate a love-triangle situation involving two women and a man. The transparencies were photographed and planned specifically for a sandwich. For this project a 2¹/₄" camera was used.

One shot was a closeup of a girl's face; the other showed, in full length, a semi-silhouetted couple facing each other. Although they were almost embracing, their bodies did not touch, as this would have been confusing in a silhouette. I shot the girl's head in the first shot, very high key, with the left side lighter, and looking up towards the left. I put a piece of glass patterned with very fine vertical lines in front of her to soften the face just enough to keep it from being overly sharp and realistic. I didn't shoot the couple until the transparencies of the girl were returned from the color lab. I cut out one of the frames and laid it on the viewfinder as a guide while photographing the couple. Because this transparency was to be used in a sandwich, I photographed the couple on a white background. I composed the shot so that when it would be laid on top of the picture of the girl's face, the couple would be on the left side of the face. I shot it sharp, and to create an elongated effect I also shot it out-of-focus. I was careful to make sure that the tops of their heads

reached the top of the girl's head, and that their feet were near the bottom of her chin. I repeat, while shooting the couple, I was looking through the viewfinder with a transparency of the girl's face lying on it. It was so well planned that, when the results of the take of the couple were sandwiched with the girl's large head, she appeared to be looking at them. Neither transparency obliterated the other; instead, they enhanced each other (Fig. 9-4). When shooting for sandwiching, it is important that the sizes of the important areas, the tonal balances, and the placement in the composition be coordinated and planned.

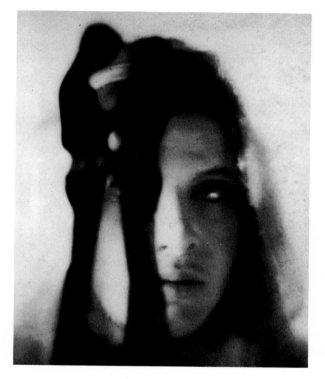

Fig. 9-4. A sandwich of a girl and a silhouetted couple.

Now I come to a project where an art director for a large paperback book company, Barbara Bertoli, and I had to create seven related covers for a series of books. Each of the seven books was about the same person, but in each book that person lived in a different epoch and in a different place. The problem we had was to convey to the public that the books were connected, but that each book was different. We needed an underlying theme with variations.

After our first conference, Barbara and I decided to use sandwiching. I returned to see her with a selection of slides from my file, which I chose because I thought they might have some bearing on our problem. The slides were not intended for use, except as a reference and an inspiration. We could have used double exposures, or projections. We decided to use a sandwich of the same face for each cover, and to place inside the area of that face a picture of a scene, an object, or a work of art symbolic of the seven different places and epochs. We also decided that each cover would have its own dominant color. The type and the format would be the same for each book in the series, and, needless to say, the titles and the copy would change. A $2^{1}/_{4}''$ camera was to be used for this project.

Because of the specifics of this particular problem, I became strongly aware that if you eliminate the contours of the face and reduce the face to a two-dimensional plane, the eyes, the eyebrows, the nostrils, and the lips take up, at the most, $^{1}/_{8}$ of the overall facial area. This leaves the balance of the undisturbed areas of the forehead, the cheeks, the nose, the part between the upper lip and the nostrils, and the chin, onto which you can add design and other pictorial material. You can eliminate the contours of the face only if you allow no shadows and have absolutely flat lighting. A study of paintings, drawings, and photographs where there were no shadows, particularly Chinese and Japanese art, will make this very clear to you.

After Barbara and I chose the model, I photographed the model's face in closeup many times, from the same direct front angle, with the same flat lighting, changing only the color filters on the lens and the color scrims on the lights. I used a wide exposure bracketing, and shot lots and lots of pictures. Since I was not going to double expose, I did not make an exposure chart. An absolutely black background being necessary, however, I did make sure that there was plenty of room between the model and the background so no light would spill onto it.

When the transparencies of the model's face came back from the lab, I cut one out and put it in the viewfinder as a guide, so that when I would choose the material to be sandwiched and study it through the camera viewfinder, I could make sure it would fit in the transparency properly. A good deal of time was spent in research, finding material appropriate for each book.

In photographing this material, camera distances had to be adjusted, and close-up lens attachments had to be used. Sometimes two or three possibilities had to be discarded until we got one that fit the face and at the same time conveyed the right message about the era and location pertinent to each particular book. It was a challenging and interesting project, and entailed much hard work (Plate 1).

Now I come to a project that required a combination of several techniques. It was a virtuoso performance, with a sandwich that was

116

anticipated and planned for ahead of time thrown in as a final fillip. This shooting consisted of a silhouette with edge lighting, triple exposures in tight areas, an abstract for the fourth exposure, and then the sandwich. All this was done with a 35mm camera, because that camera is best for multiple exposing, the dominant technique of this project. During the shooting, very careful diagrams had to be worked out and followed.

To begin with, I had a silhouetted, edge-lighted profile, which I shot smaller with each successive take. For take I, and take I only, a white background was used. The model was seated on a chair in a very comfortable position, with the top of her head level with the top of the chair. A black cloth was on the chair, and the cloth was pulled back at least two feet.

The model had to be very comfortable, and her head had to be supported, as the pose had to be held for a long time. My model stayed seated for the three takes, which is unusual. She could have gotten up because the chair stayed in the same place, and the position of the head resting against the back of it was marked. You could never have used a child, or someone who wasn't serious, as a model for this take.

For take I, I edge lighted her profile with a red scrim on the light, leaving the rest of her head in deep shadow. When take I was finished, I moved the camera back a little, changed the background paper to black, and put a blue scrim on the light. If the white background paper had been left up, that part of take I that fell outside of take II (i.e., the part that was larger than take II) would be washed out. The profiles of takes II and III could only be used to the left of the edge-lighted profile of take I. Or to describe it another way, the profiles of takes II and III had to fall inside the larger and much darker area of the profile created by take I. For take III, I left the black background up, changed the scrim on the light to yellow, and moved the camera a little to make the head smaller (Fig. 9-5).

Fig. 9-5. The three takes of the model's profile as seen through the viewfinder.

EXPOSURE CHART FOR EDGE-LIGHTED PROFILE
Light Reading for All Three Takes: f/5.6 at 1/30 sec.

Frame #	Take I		Take II	Take III	Frame #	Take I		Take II	Take III
1	f/4	1/30	same	same	19	f/8	1/30	same	same
2	f/4–5.6	"	"	"	20	f/5.6–8	"	"	"
3	f/5.6	"	"	"	21	f/5.6	"	"	"
4	f/5.6	"	"	"	22	f/5.6	"	"	"
5	f/5.6–8	"	"	"	23	f/4–5.6	"	"	"
6	f/8	"	"	"	24	f/4	"	"	"
7	f/8	"	"	"	25	f/4	"	"	"
8	f/5.6–8	"	"	"	26	f/4–5.6	"	"	"
9	f/5.6	"	"	"	27	f/5.6	"	"	"
10	f/5.6	"	"	"	28	f/5.6	"	"	"
11	f/4–5.6	"	"	"	29	f/5.6–8	"	"	"
12	f/4	"	"	"	30	f/8	"	"	"
13	f/4	"	"	"	31	f/8	"	"	"
14	f/4–5.6	"	"	"	32	f/5.6–8	"	"	"
15	f/5.6	"	"	"	33	f/5.6	"	"	"
16	f/5.6	"	"	"	34	f/5.6	"	"	"
17	f/5.6–8	"	"	"	35	f/4–5.6	"	"	"
18	f/8	"	"	"	36	f/4	"	"	"

Shot at proper light reading—f/5.6 at 1/30 sec.—repeated 12 times; all other apertures repeated 6 times.

The only light reading with which it was necessary for me to be concerned was that on the edge-lighted profile, $f/5.6$ at 1/30 sec. (The reading on the shadow side of the face was three stops less.) The bracketing of the exposures was only one stop on each side of the reading, and included the half-stops between. Unlike other shootings, the bracketing was the same on each frame for each take since the lighting and the pose were identical. Even though the color scrims were changed, I made adjustments of the lighting distance to make the light-meter readings the same for the three takes.

For take IV, an abstract, the exposure chart was not used, and the take was bracketed independently of the chart. I felt I wanted some kind of abstract design on the overall composition, so I decided to put the roll through for a fourth take. I went out into the street at night and at speeds of 1/4 sec., 1/2 sec., and 1 second, with lens openings of $f/11$ and $f/16$, I photographed street lights, traffic lights, and moving car headlights. I purposely moved the camera during exposures. I only exposed on every other frame. I was not too sure of this fourth take, and I was not going to take the chance of spoiling the hard work of the first three takes.

Fortunately, the fourth take worked well, and gave the impression of the kind of nervous, quivering lines one sees on an electrocardiogram. These lines were relevant to the picture, as it was to be used for an article on psychiatry.

I also did some out-of-focus blobby abstracts, which could have symbolized disturbing, unclear thoughts in the woman's head. I was really excited about this project and could hardly wait until I got the film back from the color-processing lab.

I edited the slides, putting the ones with the best exposures in a separate pile, and then sorted these into three separate groups. I put the ones with no abstracts in one pile, the blobby abstracts in another pile, and those with the nervous lines in a third pile. These last were my favorites. I took a pair that matched from each group, i.e., those with identical exposures. I removed them from their mounts and flopped one transparency of each pair. I then placed all six in a single mount, facing each other like a mirror image, and got a single slide of six profiles (Fig. 9-6).

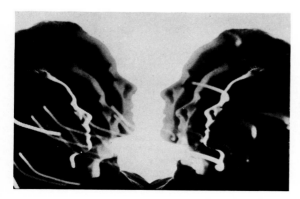

Fig. 9-6. A black-and-white version of the final shot—six profiles and streaks of light in a mysterious and moody composition.

119

SANDWICHES AND A BLACK-AND-WHITE MONTAGE

Photography, like politics, human relations, clothing styles, and the arts, goes through phases when certain things are in vogue and certain other things aren't. Very often what's "in" and "out" isn't openly stated; it's just in the air. And if you don't adhere to these unspoken "do's" and "don'ts," you are considered stupid or less than human.

Not too long ago, in photography, it was considered "bad taste" if you did soft-focus salon-type scenery, or tinted pictures, or montages. There was a time when the professionals made fun of snapshot-type photography, and bent backwards to avoid doing a so-called snapshot even in situations that called for such a picture. Ironically, now there's a movement on pushing snapshot photography as something great. Another "forbidden" was to do a portrait with the sitter posed and aware that he was being photographed. It was declared that the only good portraits were the candid ones, as if the photographer were a ghost and the sitter didn't know he was there.

I always liked everything that carried a message I wished to convey, that expressed something I felt inside, or that, I felt, reflected something meaningful in its own way. Things are getting better, and one of the things I like about life today is that everything is becoming understood and accepted for what it is. We are beginning to see all expressions as parts of the whole: short skirts, long skirts, and no skirts; abstract art and representational art; jazz music and classical music; beards and no beards; and curly hair, long straight hair, and short hair. I say, it is not the form that counts, it is the content and the intent. The form is important only insofar as it reveals, to the best advantage, the content and the intent.

My criterion is: If you are motivated by love of people, love of life, love of work, and love of self, what you're going to say and do will have a validity, and should not be disparaged. Photographs of squalor and war have this motivation of love, the kind of love that says, "It shouldn't be so." Among many, many other things, moral indignation and the passion to communicate and share are important aspects of the arts.

Well, several years ago, when it wasn't the thing to do, I decided that the essence of something I had to express could best be done with a montage. I had to create, photographically, a crowd of people. I went through my black-and-white negative file for all kinds of faces, young and old, male and female. The one thing they had to have in common was to be facing front and looking directly out. I printed about 30 of these heads, all two inches long. It was a lot of work, but fun. I then cut the heads out from the backgrounds and pasted them down on a board starting at the top, so that the top of each head would cover the cut just below the shoulder line of the head above it. What I had was a montage of many faces, obviously put together. I had made this montage for

myself; but later, I got an assignment to produce a color slide of a heterogeneous crowd, a crowd to symbolize all peoples.

I decided to attempt three solutions. The first one was to rephotograph this black-and-white montage on color film with a 35mm camera. As with the sandwich of the dancer described earlier, the 35mm camera was used, because I was going to use an overall abstract for the sandwich and no shifting would be necessary. I also planned to double expose.

I put a flesh-toned filter on the lens, varied my exposures, and varied the focus from sharp to soft. I double exposed half of the roll on a very out-of-focus abstract of muted colors. All I wanted were imperceptible blobs of color to fill in the shadow areas of the many faces. I laid out the single-take frames on the slide sorter with an assortment of abstract slides. I had already built up a large file of abstracts. I finally made three sandwiched slides of the montage with three different types of abstracts.

The second solution was a different kind of sandwich. For this one I decided to emphasize the unrelenting movement of a crowd. One evening, along with five friends, male and female, I searched until I found a low, brightly lighted store window throwing plenty of light onto the sidewalk. I needed a bright enough background to enable me to shoot at speeds fast enough to prevent blurring of the moving legs. The composition I planned was to include only the legs of the walking people. My friends kept walking back and forth, as I, kneeling on the sidewalk, kept shooting their legs. There had to enough space between the legs to show a multiplicity of legs, without the legs overlapping. One couldn't plan this, it was a situation where you had to take plenty of shots. My friends were patient and helpful. They walked back and forth. The street was not too crowded. The only planning possible was to keep my friends from getting too bunched up, or in a straight line like soldiers on parade, where all the legs melt into each other and become a solid mass. Actually, it was only when the slides came back that I decided to make a sandwich. Hard as I had tried while shooting, the legs of five people did not give me that jumbled quality, that extra something I felt was needed to convey the impact of an untold number of unrelated people close together, but moving independently. Although using a 35mm camera was easier in this kind of shooting, if I had done a retake I definitely would have used the 2^1/$_4$" camera, in order to get more latitude for sandwiching. However, sandwiching is not impossible with 35mm slides, and it was just a matter of spreading the whole take out on the slide sorter, and finding slides where the spaces, the legs, and the movement would fall in the right places. You must patiently lay one slide over the other until you get a combination that works (Fig. 9-7).

The art director had asked for something symbolic to catch the essence, the spirit, of a crowd, rather than just another picture of an actual crowd; but I knew from prior experience that although clients will

121

say they want something different, they often end up wanting the obvious or the classic, or just the same old treatment of the tried and true. But that's true of a lot of things, and one shouldn't be discouraged or disheartened. I've always accepted the challenge to discover a new, an original, and a different way of expressing an idea. And then, there is always the chance that I would stumble on something new and exciting that, if not usable for the immediate problem, could be used later in a different situation.

I was satisfied that I had tried the new and the different, but from experience, as a third solution to the assignment, I decided to do the obvious just to keep myself covered. At 4 P.M., in the late spring, when it was still light, I went to the Staten Island Ferry terminal. With the camera, I stood in the broad window that is right over the entrance. From there, there is a box-seat view of the many streets that feed into the plaza in front of the terminal. At about 4:30 P.M. people start pouring down these streets, and droves of them come together and move in a mass into the terminal, right under you, as you stand in the window. It's like being the Pope at St. Peter's, or Cecil B. deMille during the filming of an epic. Ensconced in my super-duper spot, I just kept shooting pictures of this mass of people. Although I did not anticipate a sandwich for this situation, I used a 2¼" camera. As 5 P.M. approached, the crescendo and the enormity of this mass of people reached a peak, and the crowd became an almost single, massive body of movement.

This was the transparency the art director chose. We made a sandwich, not because we needed a more dense crowd, but mainly because the art director didn't want just a simple photograph of a crowd; and we also wanted to avoid any identification of a single person. In this sandwich, with bodies overlapping and parts of bodies obliterated, the individuals in the crowd were broken up and in a way atomized. The sandwich thus transformed the individual pictures from photographs of a "going-home-from-work" crowd to a more universal, a more symbolic crowd. So, in the end, the solution wasn't so ordinary or run-of-the-mill.

When you have the transparencies on the light box, and you start to

Fig. 9-7. A sandwich that jumbles several people together to create the effect of a crowd.

work putting one on top of the other until you get a new image out of two existing ones, an image that either matches an idea that you have or an unforeseen image, you have engaged in a special form of photographic creativity.

COLOR MONTAGES

Sandwiches and montages are similar, not quite brother and sister, but perhaps cousins. Earlier I described a montage made with black-and-white prints. Now I will describe montages made with color transparencies.

I had to recreate, in a photograph, a sense of the density, the crowdedness, and the kaleidoscopic and tumultuous qualities of the city. I went out and shot many pictures around the city, in the streets and from a rooftop. For some frames, I masked the lens with a teardrop-shaped aluminum funnel. As I sat in my studio and spread the whole roll of slides out on the slide sorter, I liked one or two shots; but generally I was dissatisfied.

Thinking of the montage of the people's faces, described previously, I got the idea of cutting up these 35mm color transparencies and making the bits and pieces into a montage by glueing them on clear acetate and reassembling them into a 35mm format. A 35mm slide seems small enough, and it would appear to be ridiculous or impossible to cut little pieces out of it, but I thought I would try it with some slides that weren't doing me any good anyway.

For this kind of montage, acetate or a piece of clear film is needed. The clear acetate can be purchased in art stores, or you can get empty acetate sleeves, used to cover uncut strips of 35mm color transparency film, from a color-processing lab. I cut a piece of clear acetate to the size of a single 35mm frame and placed it inside an open mount. I then took about six city slides and began to cut them up with a single-edge razor blade, extracting buildings and pieces of buildings. I dipped a toothpick in clear glue and put a dot of glue on a piece of slide and placed it on the clear acetate. I moved the little pieces of slides around. Some of the pieces overlapped. There was little control over the composition, it composed itself haphazardly. The lines of the cut edges gave the whole thing an overall webbed pattern that did not distract from, but con-tributed to, the effect of a many-layered city. I covered the city montage with one frame of an overall abstract design, and sealed the mount. I put the slide in the projector. You need this kind of a blowup to be able to see a thing like this. I had a great slide. The montage did what I had been unable to accomplish with a single-take photograph. Of the 140 color slides I submitted to the Museum of Contemporary Crafts for an exhibition of photography called "Photo Media" (October, 1970 through January, 1971), this slide and another montage, next to be described,

were among the 12 slides of mine chosen to be shown in the exhibition.

The work described in this book covers the gamut from the extremely precise to the accidental. In making these montages, you are working with tiny pieces, so you cannot plan carefully. You must have an overall concept of what you want, and then let it work itself out.

For the second montage that was in the "Photo Media" show, I took a group of slides of agitated faces reflected in polystyrene, a close-up slide of a face with large, staring, transfixed eyes, and a slide of a cat in a crouched position. I glued pieces of these three slides onto a slide of a work of art; the slide's colors had gone sour. I pushed the little pieces around, again not concerning myself with overlapping, just making sure that the part I considered important would show. I could not control the slant of the small pieces of film, and they went off at different angles. The slide was effective, as it helped express an emotional disjointedness, a disturbed human condition.

We are now more than halfway through the book, and we have covered a tremendous amount of work: multiple exposures, reflective surfaces, special devices, projections, silhouettes, sandwiches, montages, and so on. I assume that you will have tried many of these techniques, that you already learned a great deal, and that you have an understanding of the possibilities within your grasp, just by having done things. So much that one learns comes, I feel, by an intellectual process combined with the physical act of working, and I find that what first appeared to be difficult becomes simple in the doing. Imagine arriving in this world fully grown and trying to learn to walk or to eat from written instructions. These natural things, broken down and analyzed, would boggle the mind and sound unbelievably complicated. So I feel it is with some of the work in this book: No matter how farfetched it might sound, believe me, if you take it one step at a time, and start working, everything will start flowing quite naturally.

Not really apropos, but somehow connected, is a remark a friend of mine once made. He'd been afraid to take pictures, even snapshots, feeling he didn't want to be bothered with what he felt was mechanically complicated. I set the time and aperture settings on a camera, handed it to him and asked him to take some pictures. He found that he couldn't stop; he got carried away, and in about ten minutes went through a 36-exposure roll, jumping around, changing compositions, moving in closer, further away, the whole bit. When he was done, he said, "I don't know what happened, having a camera in your hand is like being an alcoholic, once you start you can't stop, you have to take another picture, and another, and another." Well, we all know it is something like that: The work itself contains its own fuel, reenergizing you as you go along. At least, that's how it is for me.

10
Odds and Ends

LIGHTING

No matter what kind of a studio or working space you have, I presume that you have lighting equipment that you are used to and like working with; and that you are the best judge of what equipment is best suited to what you do and the place in which you do it. My concern in this book has been about the way you work with the lighting equipment, and that is what is important.

You can get as good results from the most inexpensive lighting setup as you can with the most expensive. I happen to like the simple clamp socket, with the 8", 10", and 12" screw-on reflectors. These weigh very little, are easy to handle, and can be stored in a minimum amount of space. They take up to a 500-watt bulb. I also use Mole-Richardson Baby-Soft Lights, Type 2581. They are quartz lights, which means that the outer shell is so highly resistant to heat that a tiny and long-lasting 800-watt bulb is possible. These quartz lights are extremely well-balanced for photographing with color film. With the stand, they cost around $100.

The type of lighting you use influences what you produce. The types of artificial lighting available during different periods in history, and the natural lighting in different geographical places, greatly influenced the work of painters. The candlelight of Rembrandt's time gave his work a soft warm glow, a subtle color and light quality that we hardly know. The bright, open light of southern France certainly influenced Van Gogh's landscapes, and Picasso's later work. The tone and color in the work of a contemporary painter, Alice Neel, changed drastically when she moved from one apartment to another.

If you study the lighting in the theater—at plays, opera, ballet, or the movies—you can get many ideas. The lighting in an old building is totally different than the lighting in a modern structure. So many things influence interior lighting: the fixtures, the proportions of the rooms, the color of the walls, the size of the windows, the height of the ceilings, and so on. Outside, there are innumerable influences on lighting, the most important of which are the time of the day and the season of the year. Of course, you can't discount the geography—the amount of foliage, the openness, the proximity to bodies of water, the distance from the equator, the weather. One can go on and on. All that I want to bring to your attention is that since we exist in light, we sometimes take it for granted; you should stop and observe light, and work with it. Don't be afraid to shoot in all kinds of lighting situations. I feel that instructions that tell you to not shoot in such and such light, or at such and such a time of the day or night, are detrimental. They close the mind and many, many things are lost because of it. You're not stupid. Use your judgment. If you want to try something, go ahead and try it. It's not so terrible to make a mistake, and you might come up with something wonderful. I can name photographer after photographer who produced outstanding, beautiful photographs that have become a part of our heritage because he or she didn't pay attention to instructions.

Once, a woman in a very agitated state ran up to me to stop me from taking a picture in the Oak Creek Canyon in Arizona because, she said, "The sun is in the wrong place." Those were her exact words, and I don't think she had an inkling of the enormous insanity of that remark. Sometimes, if I've taken some night shots, I will rewind the film and, at very high aperture and time settings, hold the lens about one foot from orange warning lights on street-repair scaffolding and expose three or four frames. I've heard passers-by say, "That lady's crazy, she digs orange lights." Well, I do. I've gotten beautiful, warm, unaccountable color in slides from those orange lights.

Once you have opened yourself up to light, once you see it and feel what it is, it almost becomes an animate thing; and you start working with it, handling it, molding it, directing it, and editing it. You start creating mechanical devices to enable you to do this. You can make hoods, cones, funnels, baffles, and masks to hang on reflector floods or spotlights. Or, think in reverse. Think of light from the other end, the lens, the door through which you let the light enter that magic black chamber inside the camera where the light does its thing with the film. You can hang your light devices—funnels, masks, and the like—on the lens, to direct, edit, and mold the light just before it goes inside.

The clamps of my "cheap" lights would sometimes slip on the slender lightpoles, causing the light to fall off the place on which I wanted it to shine; so just as important as any of the other devices were the small

rectangular pieces I cut from an old rubber bathmat to fit inside the clamps so they would hold the pathway of the light firmly in place. Soft plastic kitchen sponges do this job too.

In your working space you can also use lighting from unlikely sources. Look at someone's face as he is bent over the slide viewer in a darkened room, and see the way his facial color and expression changes as each slide goes through. Make use of that phenomenon.

Another lighting source with its own special quality is the projector. (This is apart from its use as discussed in Chapter 8.) The light that comes out of a projector is so concentrated that it can be used as a hot spot that you can very easily control and direct. (But use it carefully, because if it is beamed too directly into someone's face, it can hurt his eyes.) Make slides of different colored gels, insert one of them in the projector, and you have a wonderful colored spotlight. You can also use the projector to get a shaped beam of light by making slides out of black paper with specifically designed holes in the shapes of circles, ovals, slits, squares, and so on. These you can then project on whatever subject matter you wish.

You can put the projector off to the side, out of the range of the camera, and with abstract slides get splattered shapes and colors on the background. Or, use abstract slides to throw color and design on any subject, and combine this lighting source with regular lighting.

Although I've already covered this topic in Chapter 5, I'd like to remind you again of the variety of useable lighting available outside the studio—street lights, theaters, stores, lobbies, restaurants, automobile headlights, and the like. I could go on forever. Lighting is available all over; go out, see it, capture it, and use it.

DISTORTION DEVICES BETWEEN CAMERA AND SUBJECT

There are many devices for use in between the camera and the subject; you'll find you improvise with them at a time when you are confronted with a specific problem and you have to come up with a solution right then and there. (Of course, these are other than the standard devices we've already discussed, such as the star filter and color filters.) You use these devices any place from right in front of the lens up to the subject or object you are photographing. In Chapter 3, some of these devices were mentioned as they are used in creating abstracts. Here we'll concentrate on their use with other subject matter.

One device I made was an 11" × 14" piece of stiff clear acetate with small pieces of colored cellophane scattered on it. I have also used colored clear acetate with the cellophane. These handy devices slightly soften the image; and the pieces of cellophane, in varying degrees of out of focus, add an indefinable quality to your picture. In addition, you can move the sheet and control where the blobs of color fall.

Fig. 10-1A. A plain piece of acetate is placed between the model and the camera. One light is on the acetate and one on the model so both will show up in the final shot.

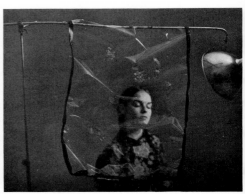

Fig. 10-1B. The acetate with the pieces of colored cellophane glued on it.

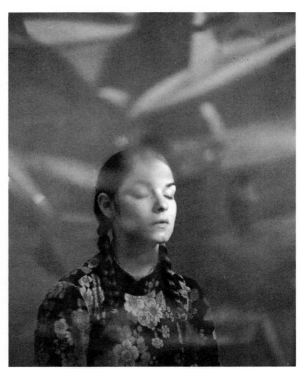

Fig. 10-1C. Using a shallow depth of field and focusing on the model through the colored cellophane creates an interesting and affecting picture.

I've also taken a large piece of glass, put sequins and brightly colored glass gems on it, and attached it to a chair (Fig. 10-2). This is good when shooting large objects or full-length figures. A piece of glass used this way, with or without embellishments on it, will allow the model to be seen through it, and also reflect what is on the side opposite the model. This is similar to the effect you see with store windows, when you see through to the display at the same time you see the reflection of the people looking in the window (Fig. 10-3).

Fig. 10-2. The setup for the shot through the glass covered with colored sequins and gems. The model and the glass must each be lighted so both will show up in the picture.

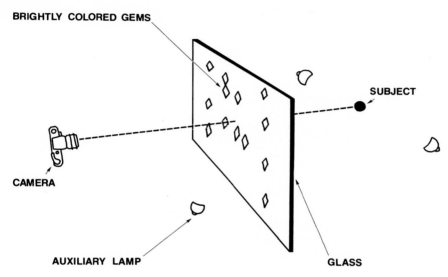

BRIGHTLY COLORED GEMS

SUBJECT

CAMERA

AUXILIARY LAMP

GLASS

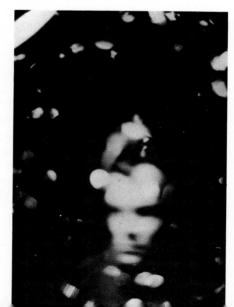

Fig. 10-3. This is one type of shot that can be made with the glass-and-sequins setup.

You can deliberately place a light (or lights) so that it will be reflected on the glass, and you will get a blob of light or a partial obliteration of the subject that might be useful for your picture. To do this, start off with a light on your side of the glass, study the subject on the other side of the glass through the camera, and shift the light until it is reflected where you want it on the glass. I have used several small lights this way, with different colors of cellophane on them, and gotten blobs of red, blue, green, or yellow floating around a model. When angled a certain way, this glass will reflect parts of your studio that you may wish to include in your picture. In my case it is generally the window and the scene behind me that is reflected. You can also use the glass solely as a reflective surface. There are times, for example, when I have deliberately placed a person in a position where he is reflected in the glass, with ghost-like effect.

Prisms, already discussed in Chapter 3 in connection with abstracts, can also be used with people. Held in front of the lens, prisms break up the color and give you a rainbow on your highlights. They also will reflect onto the film that which is off at an angle from the camera lens. You should turn the prism all sorts of ways as you're looking in the viewfinder; study the changing effects, and be aware of another, extra image entering the camera. If this "extra-image effect" intrigues you, you can use it: Put something you want to have in the photograph off at an angle from the lens, where the prism will pick it up as an extra image. The exposures can be difficult to get, but a wide exposure bracketing can help you.

Pieces of patterned glass, with patterns varying from the subtle to the complicated can be very handy. These pieces of glass should be large enough to cover the model's head and shoulders when placed right in front of her. These patterned pieces of glass are also good with still lifes. You can also reflect lights in the same way you would with the plain glass; unlike the plain glass, however, the patterned glass does not reflect images. One general rule for using the patterned glass: The closer the glass is to the subject, the less distortion there will be.

On page 114, there is a description of a sandwich of a girl's head and a couple. You will note that a patterned piece of glass was used in the closeup of the girl's face.

Recently, I did a portrait for a sitter who desired distortion because he needed something attention-getting and offbeat for a brochure and a poster. We used two types of patterned glass, one that had slight vertical lines and another that was heavily mottled, thus giving a lot of distortion. I also had the sitter put his hand in front of the glass for one photograph, so that we would have a contrast between the distorted and the undistorted.

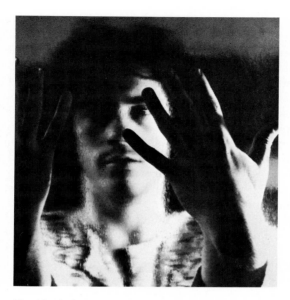

Fig. 10-4A. A lightly-patterned glass will distort the model only slightly as demonstrated in this illustration.

Fig. 10-4B. Here the glass pattern is much heavier, causing greater distortion.

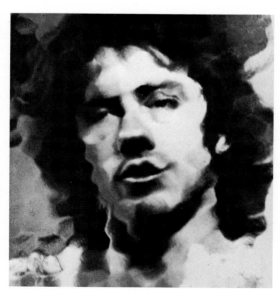

Sheets of cellophane can be used the same way as the glass. You can get different colored rolls in gift-wrapping shops. They are very important. Something I haven't yet tried, but you might find useful, is to hang several different colors in long lengths, as they come off the roll or with different degrees of crumpling, between yourself and the model.

I've also used clear plastic sheeting as a device. One particularly successful use of the sheeting occurred when I splattered red paint on it, let the paint drip down a little, then laid it flat and let it dry. The sheet was then hung from the horizontal bar of the light stand, in front of two very realistic white masks that resembled death masks, and a picture was taken. I believe red drops of paint would not have been as effective had they been put on the masks directly. However, on the plastic sheet they indicated something macabre.

In a display-supply house, I found a clear plastic sheet on which there was an outsize line drawing of an ornate carved frame. I hung this plastic sheet in front of a girl kneeling on the floor holding her head in her hand, for a photograph illustrating a person in psychological distress. The photograph made us feel we were on the inside of a mirror into which the girl was looking to discover something very private inside herself. The frame was obviously not real, but that did not decrease the impact. (See Fig. 5-9.)

I have found objects to use as in-between devices in toy stores and art stores—funny mirrors, plastic lenses, and so on. In an art store, I purchased a multiviewer, a series of 25 flat oval condensing lenses imprinted on a clear, hard, stiff plastic sheet, 9" × 12". I put the multiviewer in front of a man's face; each diminishing lens picked up his face, so the photograph was of 25 heads inside a normal-sized head, which showed through the clear section of the plastic sheet (Fig. 10-5). A small plant used with the multiviewer came out as 25 smaller plants.

On exhibit in an art gallery was a flat plastic magnifying lens as part of a large sculpture. A child in the gallery was using the sculpture to play hide-and-seek with a friend, and they were delighted with this magnifying lens. I had my camera with me, and took a picture; in the photograph the child's enlarged head seems very strange because of her tiny hands in front of the magnifying lens.

A few blades of grass, held in front of the lens, can be a useful device. I have used plastic ferns that way while shooting in the studio. With a black background behind the model, I then did a take II of a large clump of the ferns; I increased the quantity of the ferns by putting a mirror behind them, and including both the real and the reflected ferns in the take II. In the finished slide, the model appears to be submerged in a mass of ferns.

There's a funny story about how photographers grab at anything to hold in front of the lens to embellish a still photograph, told by a friend of

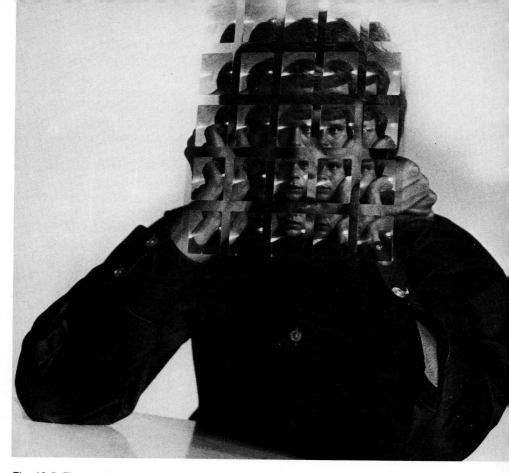

Fig. 10-5. The multiviewer splits the image into many separate and distinct elements, creating an interesting and unusual effect.

mine who was on location doing stills for a movie that was being shot. He held some grass in front of the bottom half of the lens, and after that every day the actors would bring him offerings: empty cigarette packages, wax-paper sandwich wrappings, plastic containers, drink stirrers, flowers, broken glass, and the like. And of course everyone had a laugh when he actually used some of these things.

A great device I have is a pipe cleaner made of copper-colored foil. I twist one end around in a spiral and hold it close to the lens; it throws scattered little gold glints all over the transparency. Of course, I check before shooting to see exactly what the pipe cleaner will do by pressing the depth-of-field previewer button. This is a precaution you must take with all these devices. They are great when they enhance or contribute something to a picture, but remember, if you are not careful, they can also spoil a picture.

133

WILD SHOOTING

After you've followed the directions carefully and deliberately, and have achieved a grasp and an understanding of the different techniques, and also had the satisfaction of seeing results, give yourself the present of "wild" shooting. Don't mark the film, don't make diagrams. Pick a subject and do all kinds of things with it. As far as I am concerned, you can take as much credit for good accidental results as you can for carefully planned results. I had fun doing close-up heads, fully lighted and double exposed on crowds waiting to get into rock concerts. A friend of mine went out into the street and photographed traffic scenes and buildings during the day with a pink filter. He then put the film through again without taking the precaution of matching the frames, and photographed similar things but with a green filter on the lens. He then put the roll through again at night, deliberately underexposing. Every so often you can see a reddish glow from some of the lights, because he used daylight-balanced film with artificial lighting, but nevertheless his results were unique. Although the city is unplanned, disorganized, and congested, in my friend's "wild" transparencies the city emerges with an organized design. There are vertical and horizontal shapes on top of each other. The unmatched frame lines did not distract, and those that showed merged into the overall graph-like design. He had long horizontal prints made, covering approximately $1\frac{1}{2}$ frames, and put them in a show. Because of the contemporary movement to sell photographic prints as art, three of the prints were sold for $100 each.

Shooting "wildly" is opening yourself up to an adventure that welcomes the unexpected. If you have knowledge, experience, and a visual concept, "wild" shooting can be good. "Wild" shooting can also produce an unattractive jumble, but that's the gamble you take.

I have never really been able to shoot without marking the film. Something inside of me demands that the frame lines match. I guess, despite everything I have said, I do have a respect for technique. But, beyond using "prepared" rolls of film, I have shot "wildly," out of a love for the experimental and the new.

For one "wild" shooting session, I used a dancer. I put on a recording of Schubert Piano Impromptus, and the dancer just improvised. I also, so to speak, improvised. With a "prepared" roll of film in the camera, I made an innumerable quantity of shots: in- and out-of-focus; from a low angle near the floor; standing on a ladder and shooting down on the dancer curled up on the floor; holding the camera still and moving the camera during exposures. I did silhouettes of the dancer making arm movements in a sitting position. She changed costumes from black leotards and tights to white. To contrast her costumes, I changed the background paper from white to black.

I did not keep notes. I did not even number my rolls of film. I went out and did a variety of shootings for take II's. One of my take II's was of the crystal ball in its mirrored setting. (See Chapter 4.) The results from that particular shooting showed a curled-up creature floating in a yellow space containing many spheres (Plate 14).

In another group of pictures with the crystal ball as the take II, the dancer was kneeling in profile with her arms out, and she seemed to be tossing large pastel balls. I was delighted with these results too. It was all surprise, surprise, surprise, like going to a grab-bag party when you were a kid. Allowing the accidental to happen and getting good results is like letting go and having a "free" ride on the camera.

One transparency of the dancer in her black outfit with her legs in a lunging position, her back arched, her head thrown back, and her arms curved, was a double exposure on the plastic head of a leering skull that I photographed in an art gallery. Although unplanned, the placement was perfect, the mood was right, the pieces fitted together perfectly, and I sold the transparency for a cover for a book on extrasensory perception.

I did another "wild" shooting of a young couple dancing to rock and roll music. Take II's were abstracts using symbols of youth. Two of the pictures from this session, along with slides mentioned in Chapter 6, were used in a *U.S. Camera* magazine story entitled "Fantasy Photography." In one double-exposed transparency, the couple was dancing on concentric-circle designs; I got the concentric patterns from automobile-headlight covers that I set up in the studio with colored Christmas lights behind them. The other double-exposed transparency showed the couple superimposed on a vividly painted motorcycle that I discovered spotlighted in a window display. This was another stroke of luck. The motorcycle was in an antique-shop window on 57th Street in New York City. When I arrived the shop was closed, but a cleaning man inside the store seemed to understand what I wanted, and he turned the spotlight on for me.

Another time, I threw the rules away after getting exhausted from working on a "very-tight-to-the-layout" job. This was a so-called simple job, where the elements were reduced to the few essentials of the back of a girl's head, her long blond hair, and her bare shoulders. The tight and exact cropping and focusing, the high-key tonality, and the background color had to be matched to a color swatch, a monotone high-key dreamy effect with flat lighting. I used a flesh-toned lens filter to blend the tones of the skin, the hair, and the background.

When we were finished, the model and I decided to relax. She turned around, and I lighted her quickly from the side and did three takes on one roll, just changing the size of her head; I made no diagrams. The results were quite startling—eyes, cheeks, and white edge-lighted profiles appeared inside the facial shadows on the large front-view shots.

TIGHT AREAS

This is the complete reverse of "wild" shooting. I did two double-exposure projects where take II had to be placed in a specific, small area of take I. In one project the area was less than 1/4 of the total slide area, and in the second project the area was about 1/8 the total slide area. When you think that the total picture area of a 35mm slide is 24 × 36mm, which transposed to more familiar measurements is 1" × 1½", you can understand how tiny that is. Exposure charts are important for this kind of precise shooting, but diagrams are absolutely indispensable. Without them you cannot possibly accomplish anything.

The first project was something I assigned myself. I found a round black-glass perfume bottle with a slightly flat bottom, a short thick neck, and a gold ball stopper. That shape presented a challenge to which I had to respond. After spending time really looking at the bottle, I decided to try to put a girl inside it (with my camera, that is). So I went to work. The first take was very simple: I had a white background, the camera on a tripod, and I kept the bottle, close-up, in the same placement in the frame throughout the take. The difficult part would be the second take. For take II, I got a dancer dressed in orange tights and a leotard into the studio. She moved around against a black background, and when her movements fit into the central area of the bottle, I pressed the button. The only direction I gave her was to ask her to remain in one place so that I wouldn't have to constantly adjust the focus. You'd be amazed at how much movement there is in just the body, the arms, the legs, and the head, even if the person stays in one spot. (Think of dancers from India. They hardly ever make steps and yet they can go on for hours without repeating themselves.) During this particular take we got a lot of sitting, kneeling, and lying-down poses. Unlike painting and drawing, where you see exactly what you are doing as you are doing it, photography (except for Polaroid pictures), forces you into that time gap between the doing and the seeing. There are times when it can be excruciating. But as they say, that's the nature of the beast, and you learn to live with it. Well, I got the results of this shooting, and despite the smallness and the exactness of the area, the girl was inside the bottle in three-quarters of the pictures (Fig. 10-6).

Soon after working out this problem successfully, and putting one of the slides in my portfolio, an art director phoned and asked if I could produce a color slide of a girl's face inside an emerald ring. "Of course, I can," I replied. Incidentally, I almost always say yes to requests like that, even if I haven't previously tried to do them. In this case, a cover was needed for a mystery book about murders committed over an emerald ring. The problem was similar to that of the girl in the bottle, and I was therefore prepared to complete the assignment. I shopped around for

Fig. 10-6. A girl in a bottle.

costume jewelry, and found a ring with a very large tear-shaped green stone. Not wanting to be limited only to such a small object, I bought a large, green, rectangular-faceted stone (actually cut glass) as an alternate, and glued it to a hoop earring. In a photograph it would look like a ring, if there was nothing in the picture with which its size could be compared.

The art director chose a strong yellow background. The plan for take I was to place the ring in the lower half of the vertical frame. Room for copy is something you must always think of in commercial jobs. The presence of copy on the cover meant that the film area the stone would occupy was something less than 1/8 of the total picture area; and this was the area into which I had to place a girl's face wearing an expression of terror and fear.

A tripod was imperative for both takes. I used two rolls of film, one for the tear-shaped ring, and the other for the improvised ring. For take I, exposures were varied five ways, including the half-stops; I went 1^1/$_2$ stops over and 1^1/$_2$ stops under the reading. The lighting for take I was simple, just enough to pick up the background color and a few green highlights in the facets of the "gem." In cases like this the light meter that is attached to the camera is inadequate, unless it is the kind that can zero in on a very small area. This is a very touchy kind of shooting. Besides the almost pinpoint placement of take II, and the sharp focus for both takes, the girl's facial expressions were of utmost importance.

Two rolls of film were about the minimum I needed to come up with the right combinations. Since I needed someone who could act, I chose an actress for the job. She and I rehearsed before shooting. I explained the need to project fear and terror in a very confined area. We tried several things—different arm movements and different head angles. We decided to limit ourselves to one pose; front view, with the mouth open to simulate screaming, and clenched fists close to the face. The lighting setup was a light on each side of the face. To insure that only her hands and face would show in the photograph, she wore a long-sleeved black turtle-necked shirt, and of course I used a black background.

To keep her in the same position throughout the shooting, I placed a black-covered table in front of her, and sat her in a black-covered chair. To get a genuine expression, she clenched and unclenched her fists and screamed for each shot. Besides remaining totally concentrated on the actress and encouraging her, I still had to follow my exposure chart, change the aperture for each frame, check the focus and the placement, and make sure I pressed the button at the same time she hit her peak (Fig. 10-7).

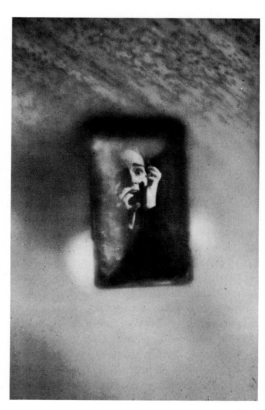

Fig. 10-7. A girl trapped inside a ring.

EXPOSURE CHART FOR SHOT OF GIRL INSIDE RING
Light Reading for Take I, Emerald Ring, f/5.6 at 1/10 sec.
Light Reading for Take II, Girl Screaming, f/2.8 at 1/60 sec.

Frame #	Take I		Take II		Frame #	Take I		Take II	
1	f/5.6	1/10	f/2	1/60	19	f/11–16	1/10	f/4	1/60
2	f/8	"	f/1.4	"	20	f/4–5.6	"	f/2.8	"
3	f/4	"	f/2	"	21	f/5.6–8	"	f/2	"
4	f/4–5.6	"	f/2.8	"	22	f/8–11	"	f/1.4	"
5	f/8–11	"	f/4	"	23	f/4	"	f/1.4	"
6	f/5.6–8	"	f/5.6	"	24	f/11	"	f/2	"
7	f/4	"	f/8	"	25	f/8	"	f/2.8	"
8	f/8	"	f/4	"	26	f/5.6	"	f/4	"
9	f/5.6	"	f/2.8	"	27	f/5.6	"	f/5.6	"
10	f/11	"	f/2	"	28	f/4–5.6	"	f/8	"
11	f/11–16	"	f/1.4	"	29	f/11–16	"	f/8	"
12	f/8–11	"	f/2	"	30	f/8–11	"	f/5.6	"
13	f/5.6–8	"	f/2.8	"	31	f/8–11	"	f/4	"
14	f/4–5.6	"	f/4	"	32	f/8	"	f/2.8	"
15	f/4	"	f/5.6	"	33	f/4	"	f/2	"
16	f/8	"	f/5.6	"	34	f/4	"	f/1.4	"
17	f/5.6	"	f/8	"	35	f/11	"	f/1.4	"
18	f/11	"	f/5.6	"	36	f/4	"	f/2	"

Please note: little repetition of exposure combinations

139

SPIRITS AND GHOSTS

From time to time, a book will be published claiming to have authentic pictures of ghosts in it. I understand that they sell well, and make a lot of money for their authors. Well, I am about to tell you how to make ghost and spirit pictures. It occurs to me, before I start, that perhaps I shouldn't write about how to do it, and just make believe that these are pictures of "real" ghosts. With the preponderance of interest in extrasensory perception, the occult, and ghost and spirit stories, I could have a book of spirit and ghost pictures published, claim that they are the real thing, and perhaps make a lot of money. But it wouldn't be true, and I feel life is difficult and mysterious enough without perpetrating any more misleading hoaxes.

There are two or three ways of dressing and lighting the model to make these ghost pictures. For the "classic" ghost, just hang yards and yards of white gauzy fabric on the model, covering her entirely from the top of her head to her toes. Put a light behind her for edge lighting, and use an oblique light at the side and front of the model for definition in the folds, to keep the ghost from being a white blob. You could hang very thin plastic over the white gauze, if you want highlights. Sometimes you let the face show and sometimes not. For a variation, you can hang a few different pastel-colored gauze scarfs on the model. Generally, you might use soft focus, or sharp focus with a slow time setting, and introduce slight camera movement, which I prefer to do. But try one or the other and see what you like. In shooting this "ghost" I use two takes; and for take I, I have always used a black background.

Here's a way to create a lively dancing "ghost": The model should be wearing white tights and a long-sleeved white leotard. You wrap her body, arms and legs in very thin plastic, so the body is defined, not the face. Then you have loose, raggedy strips of plastic hanging from all parts of her, especially the head and the arms, which wave around a lot, and these strips swing out as she moves and turns. Again, you work against a black background.

My favorite "spirit" is dressed in black tights and a turtle-necked long-sleeved top. Her hair is tied back, and on her head is a cap with two horn-like points going out from the sides of her head. The cap is made in about ten minutes from two black paper cones and black masking tape. It must be firmly anchored to the model's head with bobby pins and ribbons. The purpose of the horns is to spread three or four layers of soft thin plastic that are loosely draped over the top of the head so they fall down in back of her and along her sides like a great cape. They can also fall in front of her, if you like. The model uses her arms to give shape to the plastic. Two lights are placed behind her, completely hidden: They light up the plastic cape, making a great halo or cloud all around the

body, which is totally silhouetted. The background is black. You can put colored scrims on the lights if you wish or put a few small colored lights behind her. These colors get diffused in the plastic cape. This "ghost" was so effective that I photographed her only with abstracts of scattered varicolored pinpoints of lights, either still or moving (Fig. 10-8), and had that "ghost" fairly large, always dominating the photograph. (However, I could have shot her smaller like the others, and put her anywhere—in rooms, in the forest, in the city streets, in front of a house, or in a room full of people.) I also used infrared film instead of the usual Kodak High Speed Ektachrome Film (Tungsten) in shooting this ghost, just to create a different and offbeat color quality.

The first, "classic ghost" was photographed with a small amount of light on her face because I wanted to get some expression. The picture was effective; I cropped at the waist, placed the picture in the lower half of the frame, and double exposed on a night scene of a tall old country house, a shot I already explained in Chapter 5. In the same way, I double-exposed the ghost with a roadway behind her, and she appeared to be in front of an automobile that was coming down from the top of the frame. This was easily shot, with me standing on a chair, and the car parked in the right place in the driveway of the house with the headlights on. I also double-exposed this "ghost" on an old staircase with elaborate candelabra. Other good locations could have been ornate old movie-house lobbies, period rooms in historical societies and museums, or the interiors of European palaces or cathedrals. You could use old drawings and paintings for take II's.

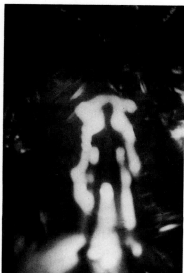

Fig. 10-8. The "ghost" double exposed on an abstract of streaky lights.

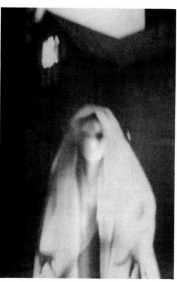

Fig. 10-9. This "ghost" was double exposed with an old house.

These suggestions hold true for any of the "ghosts." For one take II with the third "ghost" I used a black-and-white photograph, taken in the evening, of a Scottish castle. I made a hole in one of the upper windows, put a light behind it and used the star filter to make the light go into crossbeams. To photograph the castle, I put a blue filter on the lens. The "ghost," with her face showing, was in the lower half of the frame. Shot at a slow shutter speed with slight camera movement, the "ghost" appeared to have just run out of the castle (Plate 10).

I had one very effective picture of this same "ghost" with some pastel-colored strips of gauze hanging on her and with her face covered; for the double exposure, I had carefully placed her inside the black hole of a brick wall. It was only because of a diagram that I could place the "ghost" exactly inside the black hole in the brick wall of take II. In the finished transparency the creature really seemed to be coming out of the wall. I photographed a group of trees at dusk and had the "ghost" apparently emerging from the branches of the trees (Fig. 10-10). I could have put her in a dark blue sky, over the city or over woods, like a flying saucer. You could photograph her hovering over a bed with a real person in it. You might also double expose the "ghost" in a cave. We could go on and on.

The second, dancing "ghost," whom I've left for the end, is the one I actually took the most pictures of. Side lighting is best to catch highlights on the plastic wrapping and the hanging strips. This "ghost" was much livelier than the other two, and moved a lot. We screamed with laughter during the shooting as she sprawled on the floor in exaggerated, comic poses, simulating swimming and flying. Standing, she did all sorts of strange spidery movements for me, with lots of bent knee leg raises, and all sorts of wild arm and leg movements. For the take II's I used many of the locations mentioned above.

But what I did with this "ghost" that I didn't do with the others, was to make take II's of her again, in different sizes and different degrees of being out-of-focus, and to reflect her in various materials (Fig. 10-11). For instance, if my take I was sharp and small, the take II would be large, and either reflected or out-of-focus, Another thing I did with a take II of the ghost was to put the camera on a time setting and make a downward movement, so that the "ghost" would appear to be ascending. The combination of the same figure shot differently was effective.

By double exposing (or sandwiching), you can change the relative sizes of people, places, and things. When you disturb the set, established, and natural order of things, or throw them out of kilter, you produce an attention-getting image that can be either humorous or frightening. In Chapter 5 there is a more detailed investigation of shifting relative sizes.

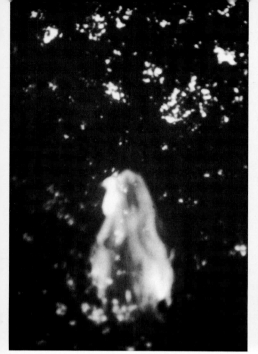

Fig. 10-10. A "ghost" emerging from the trees. Fig. 10-11. This "ghost" was reflected in a sheet of polystyrene.

INFRARED FILM

Infrared film changes the color of what you photograph. The directions on the data sheet packed with the film tell you about all kinds of filters to use with the film in order to neutralize, somewhat, this special color property and, to a limited degree, normalize the film. I advocate using infrared film without the filters, for the special color changes it creates.

When you use this film, keep note of the colors of the things you shoot, and then compare them to the colors they become on the transparencies.

Interior daylight will turn pinkish. Beaches and skies will become a deeper pink, bordering on magenta. Under artificial light, faces turn green, and a vivid red shirt becomes acid yellow. The color changes are influenced not only by the original color but also by the material. For instance, a red shirt may become acid yellow, but a red vase made from ceramic might become blue. That is not necessarily a fact, I never photographed a red vase with infrared film; the point I'm making is that all reds do not become yellow. I once took pictures of two different kinds of black fabric with infrared film, and one became dark red while the other remained black. I sometimes use infrared film when shooting wildly colored abstracts, in order to surprise myself.

143

I used infrared to take pictures on a beach one day in the spring. The beach was deserted. A friend was walking on the sand. It was chilly, and as he walked along he was hunched over and had his hands deep in his pockets. Sometimes he got far away from me, and sometimes he was close. He seemed to be deep inside himself. When I got the transparencies back, the figure was dark, and the beach, the sea, and the sky went up and down the monotone range from pale pink to deep magenta. I sandwiched three of the transparencies, with the figure of a different size in each one. This was used as a sample design for a record cover.

A trumpet player, practicing, and wearing a white shirt, came out soft pink with deeper shadows, and the instrument was a particularly bright gold.

There are times when you have to make a photograph that is very simple and straightforward. These pictures can be beautiful, and I am not advocating that you necessarily doctor every single picture that you take. However, infrared film with its deviated color can give even the most straightforward shot an offbeat, attention-getting twist (Plate 5).

PEOPLE MOVING AND CAMERA MOVING

I used four rolls of film to determine what movement did at different time settings. Only comparatively recently have pictures in which there is blur caused by movement been acceptable.

Fig. 10-12. A dance-movement picture, taken at the ballet with a slow shutter-speed setting.

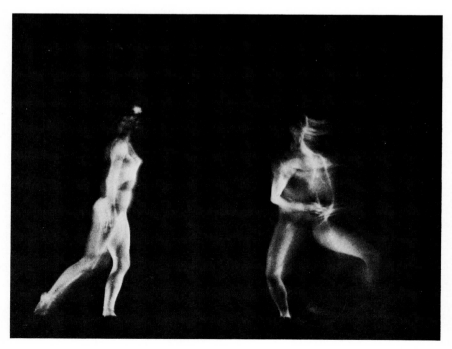

Fig. 10-13. This slow-shutter-speed shot was taken at the circus.

In 1945, a book of ballet photographs by Alexei Brodovitch called *Ballet*, with text by Edward Denby, was published. Brodovitch took the pictures from the stage wings of a theater during several performances. He shot at slow speeds, and of course there was a lot of movement and blur in the photographs. Brodovitch was the art director of *Harper's Bazaar*, and commanded a lot of respect and prestige. His book was beautifully designed, and I believe this had much to do with its acceptance, because in 1945, which isn't so long ago, this book was considered revolutionary. It opened up a whole vista of shooting with movement showing.

Shooting Chart for Same Movement

Frame #	Aperture	Time
1	f/1.4	1/60 sec.
2	f/2	1/30 "
3	f/2.8	1/15 "
4	f/4	1/8 "
5	f/5.6	1/4 "
6	f/8	1/2 "
7	f/11	1 second
8	f/16	Time

Fig. 10-14A. A traffic scene shot with slight camera movement.

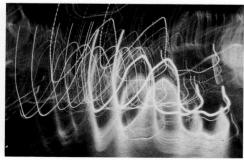

Fig. 10-14B. The same scene shot with a great deal of camera movement.

In the 1940's, Irving Penn photographed bullfights at slow speeds and in color. I remember the excitement and thrill I felt when I first saw these pictures; it was like discovering a brand-new species of flower—you knew what it was, and yet you knew you had never seen it before. You can find one series of these pictures in a book called "Moments Preserved," by Irving Penn (published, 1960), and also in a book called "The Art and Technique of Color Photography," by the staff photographers of *Vogue, House & Garden,* and *Glamour.* Incidentally, both books have many experimental color photographs in them, and the pictures still hold up; they have the same excitement about them that they had when they were first published.

Today, of course, shooting with movement showing is an accepted practice. For example, Herbert Migdoll's photographs for the Joffrey Ballet were taken at slow speeds, and they were accepted and not considered outlandish by any means.

I have gone to dance performances in studios (photography is generally not allowed in large concert halls) and shot in both black-and-white and color at slow shutter-speed settings. Some of the resulting pictures were bad; but the others were not only good, they were excellent.

It is a good idea to do a controlled study comparing subject movement with camera movement. Shoot the same movement at 1/60 sec., 1/30 sec., 1/15 sec., 1/10 sec., 1/5 sec., 1/2 sec., and 1 second, with the camera held still on a tripod. Then shoot a still pose at the same settings while moving the camera. Remember to adjust your aperture with each time-setting change, closing down one stop with each increase in the time setting. After you study the results of this controlled shooting, you might do a similar sequence of moving subjects over which you have no control, such as vehicles, children at play, people walking, and people engaged in athletic activity. You might also do the reverse: Find still situations and practice with a moving camera at different time settings. A few likely situations that come to mind are: people watching an event, people sitting in vehicles, cars stopped for a traffic light, ships and boats docked, and so on. Do all kinds of movements—vertical, horizontal, zigzag, slow, fast, and jerky, as described in Chapter 3. If you try a syncopated movement with a person as your subject, holding still for part of the exposure and then jerking the camera, the face will register during the still period, and then a blurry sweep will be attached to it.

When I first started to use camera movement, I'd move the camera without remembering exactly what kind of movements I had made, and when I would get the results I would have no idea how I had achieved them. So, if you do make camera movements, be deliberate, and take notes.

MISCELLANEOUS

I'm calling this section "miscellaneous" because in it we will cover things that weren't in any other section. These are photographs where the subject matter will be emphasized instead of the technique.

I shot an old deserted shack that had a broken window and was sinking into the ground. Back in the studio, I put a green scrim on the light, and photographed a closeup of a menacing-looking man. Thanks to the diagram I had made of the shack, I could place the head right in the window. The finished slide was scary.

Now we have an example of using the double-exposure technique to illustrate a visual concept in a play. I decided, after seeing *Hamlet*, to do a picture showing Ophelia under the surface of the water. I photographed a model in a long old-fashioned dress, lying on black background paper, holding flowers on her chest. I then did a take II on the surface of a friend's swimming pool whose bottom was a beautiful shade of blue. I had someone make ripples; and the shot worked well. I then did some take II's at a pond, including the banks with long grass and a weeping willow tree, and this worked even better.

I hope this has given you the idea to illustrate a poem, a play, or any literary work. It's a very challenging project, and it could be very interesting.

Another illustration was to show two people coming through a jungle. There are places even in our region that are heavy with trees, bushes, ferns, and vines, all of which can easily resemble a jungle in a photograph. I shot one such location as the take I, using different shades of green filters on the lens. I also used a 9" × 12" piece of green acetate with water drops splattered on it, and had someone hold it about two feet in front of the lens. Wearing a black glove, I put a finger in the lower right-hand corner of the lens to make sure that I would have a dark enough area for the take II of the two people. I so dodged every other frame.

At the studio, using two models dressed in safari-type clothes, carefully side-lighting them from above and shooting downwards, I succeeded in creating the effect, in the finished slide, of two people crashing their way through the heavy jungle foliage. Since the forest green was dark, I preferred the slides where I had not put my finger in the lower right-hand corner of the lens. The green that crept into the shadow areas on the model's faces and bodies actually enhanced the mood of the transparency.

In an experiment to find out just how light a take I could be for a take II to register on it, I decided to work with a photograph in a book as a take I. Please remember, there are strict laws about copying reproduced photographs. As photographers we should be the first to respect these

laws. Infringing on and taking over someone else's work is no different than marching into someone's house and living in it. However, if you are doing something for yourself to help you solve a problem, it is all right to copy work, but never, never allow it to be sold or reproduced. There are paintings, drawings, and photographs which are part of the public domain, but be very careful, and check everything out if you plan to copy work.

I found a photograph of the horizon along the Nile River that included a delicate fringe of palm trees. In a double exposure, the fringe of trees came out across the large eyes of a full front close-up face. The rest of the face and the scenery softly faded each other out, and the effect of two eyes staring through the trees was very good. A wide and well-mixed exposure bracketing for both takes meant that I lost a lot of transparencies, but it also insured that I got something worthwhile.

LATITUDES

Well, we've come a long way together, in and out of all kinds of changes, emphases, expansions, abstractions, sandwiches, and reflections. I hope you have had interesting adventures, and have taken many good photographs.

There is a great deal to absorb and comprehend; you will find that there is no end to this work. There are so many things to handle simultaneously: the correct exposures, the correct color balances, and the delicate meshing of all the elements. I'm sure that, besides finding out the extent of what your camera, your lens, and your film can do, you're also discovering that you can get them to do things they're not supposed to do. I call that area the area of latitudes and leeways. With a variety of combinations, you can extend the margins and the so-called limits of your materials and tools, so that the whole becomes greater than the sum of its parts.

Even though in our time the concept that technology is superior to people is being propagated, I still say that people are better than anything, because we're the ones who make the tools, we're the ones who humanize and bend the tools and materials, and make them do the extra, unforeseen things.

It is in this area that a whole world of creativity lies. I urge and encourage you to get the feel of this extra dimension; get it to work for you, then go on to make endless combinations, increase the possibilities of what you can do, and find all kinds of ways to express yourself.

This is an "Invitation to Openness." I didn't make that phrase up. It is the name of a record album by Les McCann, the jazz composer and pianist. The music is beautiful, but it is that title I love; it sums up the feeling I'm trying to get across to you.

11

Slide Show

The slides we have already accumulated are like nothing compared to what you can go on and do. You could take a central figure and develop it *ad infinitum*. You could create a series of related pictures equivalent to a novel, or illustrate a poem or an epic using a wide range of scenes, abstracts, objects, and people.

I put a slide show together consisting of many slides already in my possession and slides I shot specifically for the show. When I say slide show, I mean a series of slides put together in a dramatic sequence, preferably with an accompanying sound track. It's an exciting medium, building up interest, pacing, and impact by the interaction of the slides. The sound track will increase the impact and coherence of the slides.

You can introduce things in a slide show that would not hold up as a single slide. For instance, if you use a "terrible" slide that is extremely out-of-focus, or that has too much movement, and have it followed by a group of slides of the same subject where the focus or the speed gets progressively clearer, that "terrible" slide adds an important element to the series. In general, you can use slides that do not have too much substance by themselves, but that increase the meaning of the surrounding slides in a group. That's why I say, "Never throw anything away." Very often you will experiment and not be satisfied with the slide you get. However, you never know when you will find a use for it at a later date.

Slides can be used as bridges, as punctuation marks, as breathing spells. You can emphasize by repetition. You can set up a beat. You can create visual symbols of what is in a person's mind by juxtaposing slides. You can create time lapses or flashbacks. A slide that has one meaning on its own will get a totally different meaning when shown with other slides. You will even change the effect of a slide by taking it out of one sequence and putting it in another; try it and see what happens. Our kind of photography can be like writing fiction with a camera, and this becomes very evident in a slide show.

Still photographs are limited in their flexibility. They have to make their statement instantaneously. But a slide show is something more than just a succession of still photographs: It even has some of the characteristics of a motion picture. If you have worked on the techniques in this book, such as making sandwiches, multiple exposures, montages, and so on, you will have discovered how well the slides can interrelate.

Dr. David Randolph, of the "Project on Worship of the United Methodist Church," commissioned me to create a slide show. Its purpose was to introduce a photographic medium into the rituals of the church. It was Dr. Randolph's idea to elicit an expression from people in the arts about things concerning the church. Later this became part of a study for the National Council of Churches.

I was given about ten phrases from the New Testament in certain order, and told to do anything I felt would express the ideas I got from these phrases. If you refer back to Chapter 4, you will find a brief outline of the slide show. In fact, throughout the book, I have described slides from the show as examples of various techniques. I used many of the slides I had in my files—abstracts, multiple exposures, sandwiches, snapshots, pictures of dancers in the studio, dancers in performance, children, beautiful scenery, city scenes, and buildings. I also used some straightforward photographs of events. I combined slides I already had with slides made specifically for the project. I used every technique described in this book.

The main theme of the show was a man's trip through New York City. Symbolically, the trip was a spiritual one, one of seeking and discovery. To hold all the diverse sections together I used many slides of one man—his eye, his face, and his whole body—throughout the whole show, and tried to convey his going through the world observing, reacting, feeling and being acted upon by many different things.

I did several "prepared" rolls of his face, from many angles and with a black background, for take I's on the side, on the top, or on the bottom of the frame. I did his face and his eyes reflected in plastic materials, mirrors, and broken mirrors. I also used optical devices like magnifying lenses and prisms.

Some of the things on which I double exposed him were street scenes of the city at night, around Times Square and in the Port Authority terminal. I used the crowds on 42nd Street, shooting in the street and from a bus. I also photographed traffic, trees in the park with the sun setting, and crowds in the park. I discovered a marvelous purple mirrored lobby in a pornographic movie house that provided me with a great background. I used scenes in an off-Broadway play. I went to a street party in Brooklyn, and a discotheque. I shot the city skyline from a bridge. I took pictures of the man sitting in restaurants, gazing at merchandise in store windows, and reading movie-marquee signs.

For one sequence on 42nd Street I used a "prepared" roll of his face reflected in the broken mirror; the face was slightly distended, and one eye was tripled. Take II could fit into the category of "wild" shooting. I put the camera in the window of a bus and took pictures without even looking in the viewfinder. I was trying to get the surging crowds of people as they passed in front of the gaudily decorated theaters and stores, as though impelled by some force outside of themselves. In this accidental way, I got the outstanding slide already described in Chapter 4. It was the fragmented, agonized face of the man reflected in the broken mirror, coming through an opening in the crowd; just approaching that face is a man leaning forward on crutches, dragging his legs, totally out of step with the rest of the rushing, aimless throng. Although unplanned, it was a perfect expression of the dark side of the human condition, which I was striving to convey.

In other shots I used the words on theater and movie signs, on posters, and on advertisements. I was amazed at how often there were words and messages on these signs that were pertinent to my project. Although I used the signs and words in double exposures with the man's head, I often used them in single takes to carry a point or to give a stacatto beat to my presentation. There were times when all I wanted out of the whole sign was a single word, such as "light" or "world." In these cases I used a black funnel made with polystyrene, as explained in Chapter 4. The black funnel was actually a lens mask; it acted as an editor to single out the one word I needed out of a sign. A black funnel is more manageable than a flat black mask with a hole in it, and it does the same thing. With the black funnel, I got a take I of the word I wanted surrounded by black, unexposed film, allowing me room for a take II of the man's face, which appeared to be reading the word (Fig. 11-1).

A front view of the man's face on his own large profile, was the lead slide for the section on "Love thy neighbor, for thy neighbor is thyself." I also did many straight single shots of the man's face wearing various expressions; I made several croppings, and used all kinds of lighting, including carefully planned different color tonalities. Sometimes I would do a successive series of closeups, starting from a full head and moving in closer and closer until only the man's eye was in the frame.

This single eye was an important part of the theme. Besides the simple closeup, I used other techniques to isolate the eye. I used the plastic funnel, described in Chapter 4, which would catch light and make it whirl around and spiral down into the isolated eye. I used a small unframed magnifying glass, which the man held in front of his eye; his fingers were so extremely out-of-focus that they created an indefinite blob around the unaccountably floating eye (Fig. 11-2). There was also the enhancing effect of strange highlights bouncing off the magnifying glass, giving the slide an other-worldly effect.

I did a wide range of exposures on the single heads, on the single eyes, and on this magnified "floating" eye, all single takes. Besides using these pictures to accentuate the feeling of the man's seeing, seeking, reacting, questioning, or understanding, I would also use them for sandwiching, which requires that each transparency be thin enough to let the second slide show through, permitting the content clarity of both slides. In one instance, I used the magnified eye with a black-and-white transparency of a ballet dancer poised on toe with arms and legs extended, silhouetted on a white background. The pupil of the big eye peered out from between the dancer's outstretched arm and leg.

The closeup of the man's face was used in a sandwich with a slide of the sky with dark purple clouds, which was shot on infrared film. The eye showed through clearly in the pale pink space between the clouds. I used this slide after the section of my slide show dealing with the prosaic, commonplace aspect of life, to introduce the all-embracing and the whole (Plate 15).

A third sandwich that was effective was a straightforward shot of the man's face sandwiched with a shot of the sea: The horizon line and the sky were almost in one monotone of pale blue, and the face showed in the sky wearing a questioning expression.

Special slides made for the show can be categorized by technique as follows:

1. Multiple exposures, with no devices.
2. Multiple exposures, with black and plastic funnels.
3. Multiple exposures, with reflective surfaces.
4. Multiple exposures, with optical devices.
5. Single exposures, with optical devices.
6. Sandwiches.
7. Black-and-white photographs, copied on color film.
8. Plain single takes.
9. Series of the same subject, with changing focus and movement.
10. Pictures of words.
11. Snapshots, i.e., straight, simple, unmanipulated shots.

The opening slides were a series of abstracts symbolizing the amorphous beginning of things. These were followed by the man's face reflected in plastic material; the face was greatly distorted at first, but gradually, with each slide, it became less and less distorted, as though the man was emerging from the amorphousness of the abstracts. This particular series has already been explained in Chapter 4, the chapter on plastic reflective materials.

In the slide show I wanted to use some pictures of a play, *Georgie-Porgie*. For this I readied a "prepared" roll of film, with a take I of side-lighted closeups of the man's face exposed against the vertical side of the frame; the man would appear to be looking at the scenes in the

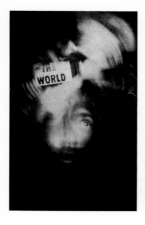

Figs. 11-1A & B. Words in a movie-marquee sign were isolated by a funnel and double exposed with the face of the man.

Fig. 11-2. An eye isolated by a magnifying glass.

play. I was looking specifically for scenes in the play that would help me unveil the meaning of my work. This take provided me with a peak point in the slide show. During a crucial moment in the play, when the main character is curled up and crying out his rage, pain, and agony while bathed in a red light, the face from take I is staring out as though he too is feeling and reacting to the pain the actor is expressing; thus the viewers feel that moment in the play more intensely. The only other bright light in the darkened theater was a little square exit sign, which, in the double exposure, fell exactly in the center of the man's forehead, just above his eyebrows, like the mark of Cain. I guess if you work hard enough, and have a strong enough concept of what you wish to express, this kind of miraculous accident will happen to you (Plate 16).

Another "miracle" occurred when I used a type of double-exposure technique for the slide show that I haven't yet described or explained. Two different images are shot with a light background, and when they are superimposed over each other, they change each other's shape and thus become a third thing. At one point during the slide show, I have a group of several similar single takes of the Father Duffy statue in Times Square. The statue shows Father Duffy standing in front of a cross.

Fig. 11-3A. The Father Duffy statue is double exposed with a word from a theater poster. Note the birds on top of the statue.

Fig. 11-3B. The Father Duffy statue is double exposed with the man's head. The birds have become a crown of thorns.

There is one sandwich of the statue and streaky, brightly colored lines made by moving the camera during an exposure on what the statue faces. It appears as though the gaudy signs of Broadway and the endless noisy traffic run over the statue, or the spirit of man that the statue symbolizes (Fig. 11-3A). Once I felt this location was strongly established, I started obliterating it by double exposing.

In the first slides of the statue, pigeons are sitting on top of the vertical beam of the cross. I double-exposed the statue on my main theme, the man. Because of the light background in the shot, the only part of the man that registered was his head, in the vertical beam of the cross. The pigeons came out right on top of his head like a crown of thorns, and the man and the cross became one (Fig. 11-3B).

The slide show proved to me that all kinds of photographs have their place. All the different types of pictures interacted with each other, and the contrast of one technique juxtaposed against another heightened and enhanced the effectiveness of each single segment. The show had a tremendous impact on its viewers.

Throughout this chapter, I kept referring to "the man." "The man" is meant to represent every man, every woman, every person, every sensitive, feeling, exultant, joyous, sorrowing, tragic human being. And so in the slide show he is and should be nameless. In real life, however, "the man" is Dan Leach, an actor; he not only worked with me as my main photographic subject, but he also took an active part in the creation of the slide show. His interest and involvement were consistent and unflagging. He was resilient, devoted, and enthusiastic. He went out with me when I had to do location shootings, and always tried to understand what I was after. He discussed problems and philosophical concepts with me, and helped develop ideas. He was as anxious as I to see the results when the slides came back from the laboratory, and he helped edit the slides. Although Dan never handled the camera, the outcome of each shooting was of as much importance to him as it was to me; and every day for three weeks we worked together to make the sound track. He was helpful, in the noblest meaning of that word.

Still photography is primarily a solo effort, but I strongly advise that if you embark on a project such as a slide show, you get someone devoted and deeply interested to work along with you. It is complicated work, and can be quite wearing, and you will find that you will need the support of a co-creator to see it through to final accomplishment.

The Mistake, or
How I Got Started

One could say I fell or stumbled, like Alice in *Through the Looking Glass*, into this kind of photography because of a mistake. It all started when I received a present of five rolls of 35mm Daylight Ektachrome film, with processing costs thrown in.

Until then I had been deeply involved in black-and-white photography. There was always one more thing I had to do, one more project nagging at me to be worked out, and I didn't want to be distracted by shooting color. I was immersed in doing travel stories, portraits, theater and dance photography, copies of paintings, and much more. The work in the darkroom never ceased to interest me. If I did do work in color, it was always in connection with a specific assignment, and only because color was requested. It was never a primary concern, and I never got caught up in it.

During a lull in my work, I decided to try out the five rolls of color film. I didn't even have an idea of what I wanted to do with them. Every photographer I know, including myself, has a pet subject. Some photographers stick with it all their lives and do nothing else. For some it is children, for others, nudes. Some just love to photograph scenery or sports. I know a photographer who takes pictures of nothing but jazz musicians. Once, when I tried to photograph a musician friend during a performance, this photographer became so irate that he stood in front of me. In his head, jazz musicians were his domain, and I was an invader. I was furious when it happened, but in retrospect, I must admire his intensity.

I became a photographer because everything in life interested me, and I was insatiably curious. Having a camera is like having a master key, you can get into everything with it. However, I do have a favorite subject that I turn to when my inspiration is at a low ebb or when I need to be recharged: It is photographing dance in all its forms, and of course

photographing the individual dancers. Once, on a volunteer basis, I became the official photographer of a modern dance group, the Dance Theater Workshop. I kept photographic records of their work and attended all their performances. I have never regretted that episode in my career.

So, with the color film, I decided to start off with photographing a young ballet dancer. I draped flowing, pastel-colored scarfs over her leotard, *a la* Isadora Duncan. I photographed her running, skipping, twirling, and leaping on a lawn. Behind her there was a solid mass of trees. It was early morning. There were long shadows on the grass, and only the dancer in her scarves caught the low rays of the sun.

I shot two rolls of film; and when I got the slides back, I was anxious to see the results. (I guess I am always anxious to see results.) The first roll looked good spread out on the slide sorter. The exposures were correct, and the dancer looked lovely and graceful, but as far as I was concerned, they were just pretty pictures. I thought they'd make good material for a record-album cover for ballet music. I was satisfied but not enthralled.

The second roll was unrecognizable. I was sure that the lab had mixed my roll up with someone else's. Before going back to the lab with the slides, I decided to project them. The dancer was in the pictures, but she was superimposed with a little boy sitting on the floor under a Christmas tree and unwrapping his Christmas presents. The pictures were awful. The dancer was shot horizontally, and the Christmas pictures had been taken vertically. However, one picture was beautiful. The dancer was in a dark green field, with colored lights all around her. What happened was that a picture of the Christmas tree, exposed only for the lights was reexposed with the shot of the dancer. Since the tree was underexposed, its sideways position didn't matter. When I photographed the dancer, the lawn and the trees were exposed for a middle tone, so the Christmas tree of the first take and the grass and the trees of the second take blended with each other. Only the dancer and the Christmas lights were bright. It had been a matter of extreme good luck. One of the Christmas lights could have blotted out the dancer's face, but nothing like that happened, and everything fell into place perfectly. Somehow, we got a picture of a dancer in a dark forest glade, surrounded by what appeared to be lanterns in the trees (Plate 3).

I studied this slide for a long time. Several things were revealed to me. I checked with the person who had given me the film. He was so embarrassed. He apologized profusely, and I thanked him profusely. He had taken the pictures at Christmas time and had vaguely missed them, but he had used at least three rolls of film at the time and had lots of similar pictures. I gave him those slides in which his little boy showed up alone.

I realized several things. First, that he shot in December, and I in May, which meant there was a five-month lapse between take I and take II. That intrigued and excited me. Second, I realized that, with care, one could construct many interesting combinations by planning the placement of the light areas and the dark areas. Third, although the frame lines meshed in this picture, if one wanted to do other double-exposures one would have to figure out a means by which the frame lines could be made to match all the time.

I was determined to continue on this pathway that had suddenly burst open for me. I decided to work out all these problems and to discover ways of controlling what had happened accidently. The gift of that double exposure went far beyond the mere fact of its beautiful appearance. The mistake my friend had made in giving me an exposed roll of film proved that one shouldn't always be perfect. One might say that the mistake was a message—but a message from where? Perhaps from a source that reveals, that leads, entices, and kicks us into situations we never would have dreamed up by ourselves. I guess this is part of the mystery of life; and the excitement of being involved in work like photography is that it takes you forward constantly into new discoveries, new possibilities. By telling you about some of my experiences, how they evolved, what I encountered, and how I proceeded, I hope to provoke and incite you to find new photographic expressions and possibilities for yourself.

Incidently, on the data sheet packed with the film, you are advised to have the film processed promptly after exposure. These precautions normally should be taken, and had this mistake not happened, I probably would never had thought of keeping an exposed roll of film around for five months waiting for the right double exposure to come along. However, if you take the simple precaution of storing color film in a cold place, there is no reason why you can not put the film back in the container, wrap it well, and store it indefinitely. No matter how long I have waited to double expose a roll of film, I have never noticed a quality deterioration in the slides: I always store my film in a refrigerator.

Immediately after the thrill and excitement of the unplanned-for and beautiful slide of the dancer, I tried to repeat something similar to it. Realizing that the essence of the shot lay in the balance between the lights and the darks of the first take and the lights and the darks of the second take, I photographed a whole roll of a friend's face close-up, and side-lighted off to one side of the frame.

I then retracted the film and went out in New York's Times Square area. It had rained, and the reflections of the many colored bright lights on the wet pavement made swirling beautiful designs. I also found giant butterflies made by neon lights reflected in stainless-steel doorways. (See Chapter 5.) I photographed all this as take II's on top of the pictures

of the head, and although a few of the highlights of take II washed out the face, there were good results. This led me to prowl the streets at all hours of the day and night, seeking reflections on car windshields and on large stainless-steel building panels; double exposing and transforming night skies pierced by skyscrapers into brilliant purple skies created out of gaudy theater lobbies; and finding the sun blazing out of dirty street puddles. But the third time I tried my new kind of color photography, I failed, because the frames weren't lined up properly at all. Although most cameras allowed you to double expose correctly, you had to double expose each frame as you shot; and for what I wanted to do, this was too confining. It necessitated having your materials or objects for double exposing ready and on hand in the same place at the same time. I almost physically struggled with this problem, knowing that the solution was right there in my hands, in the camera and the film. I experimented over and over again with a roll of black-and-white. I began to realize that when you shot a roll of film and retracted without allowing the film leader to detach itself from the take-up spool, and then started it off again, the frames would be lined up correctly. But I was not satisfied, as the important, vital thing for me was to be able to shoot a roll of pictures, take the roll of film out of the camera, and then put it back in whenever I wanted to—in the next hour, or in a day, in a week, or, as in the case of my first roll, in five months. Sitting there, with the back off the camera, staring at the film leader attached to the take-up spool, I suddenly thought of using a ball-point pen to draw a line across the film along the opening in the cassette, as explained in Chapter 1. I believe it was the force of my ardent desire which carried me to this simple solution. The solution now appears so obvious, but then it was a major breakthough; the simple and the obvious are often so hard to see when one is working on something new.

When my work began to be reproduced, many photographers, some highly proficient technically, would ask me over and over again what method I used. I would ask them what they thought I did. But they could never figure it out, and I never told them. I loved this method not only because of the types of photographs it helped me produce, but also because it by-passed engineered mechanisms.

I gave a lecture to the advanced-photography class, using many of the transparencies described in this book as illustrations. I stopped at each slide and asked the students if they could tell me how, technically, I had made the slide. Not once did the students give me the correct answer. Every time I explained the process to them, they were surprised. It was great, and I enjoyed it thoroughly, because students at all times have been active practitioners of the put down, especially with visiting lecturers, and this time the tables were turned—I never gave them a chance to do their thing on me.

Epilogue

Well, we're at the end now, and I find that I'm sorry it's over. Writing this book has been a wonderful experience, and as I did it I kept trying to visualize and reach out to all of you. I know the part of me that is in the book will be with you and the work you'll be doing.

Although this book is mainly about a carefully manipulated and controlled kind of work, I don't want to leave you with the impression that I rate any one aspect of photography above another. I believe the kinds of pictures generally carried in wallets, and the framed "corny" portraits sitting on bureau tops, are part of an individual's history, reinforcing his concept of who and what he is; they are as sacred as the history of a nation. The news pictures, to cite another example, give us a feedback of events that we share in common and that affect us all. They, too, are important.

Photography has been with us only since 1840, and in that relatively short span it has gone from being a wonder to being an integral, vital part of our lives. If possible, try to imagine yourself back into precamera times; don't you think it would be intolerable for you to live in a world without pictures?

I often think about the significance of photography and how it has given all of us a vision of ourselves. We never see ourselves except in parts—our hands, our arms, our legs, our chests, our bellies, are seen from only one angle. This is a handicap that all of us, kings and beggars alike, share in common; and this handicap keeps us yearning to see ourselves.

The camera, as well as motion pictures and TV, brought us a new self-revelation. It brought us images of people we could never hope to meet, images of places we might never see, so that we can now absorb

and experience in one lifetime what in precamera times would have taken several lifetimes to experience. Knowledge that at one time could be gained only slowly through observation, or through the written or spoken word, is now comprehended almost instantaneously through the recorded image. The camera gives us an experience and a view of ourselves, of others, of places and things, of that whole tumultuous entity called "life," that we never could have had without it.

When historians evaluate our epoch, I hope they will weigh the powerful influence of the recorded picture on the political, artistic, emotional, and scientific aspects of our lives.

I believe the camera has been as important in the evolution of human development as the wheel. The camera has accelerated the development of our intellectual and emotional capacities as much as the wheel accelerated the development of our physical mobility.

Art is both communication and revelation. Photography, too, plays this dual role, communicating between people and unveiling those qualities in ourselves that we cannot see.

As we need food to sustain us, so do we need and crave the sustenance offered by the communication, the disclosure, and the exchange of our feelings, emotions, and thoughts. The arts of painting, sculpture, literature, music, theater, dance—and photography—bestow upon us this sustenance.

I hope you will absorb the techniques and skills presented to you in this book, and will use them to express your fantasies, those beneath-the-surface images that are as much a part of us as external reality. I hope you will use these techniques and skills to express the unutterable, the tragic, the nonsensical, the lyrical, and the comic.

I think the time is fast approaching when everyone will be a good photographer, when the camera will be an extension of the body and become as common a tool as the pen or the pencil—to record facts, and to convey and reveal images of our outer and inner selves.